LOOKING EAST

BRICE MARDEN

MICHAEL MAZUR

PAT STEIR

LOOKING EAST

BRICE MARDEN

MICHAEL MAZUR

PAT STEIR

EXHIBITION
AND CATALOGUE
BY JOHN STOMBERG

ADDITIONAL ESSAY
BY CATHERINE L. BLAIS

BOSTON UNIVERSITY
ART GALLERY

JANUARY 18–FEBRUARY 24, 2002

UNIVERSITY OF WASHINGTON PRESS
SEATTLE AND LONDON

BOSTON UNIVERSITY ART GALLERY

855 Commonwealth Avenue

Boston, Massachusetts 02215

Distributed by the University of Washington Press

P. O. Box 50096, Seattle, Washington 98145

Printed in the United States of America

Library of Congress Catalogue Card Number: 2001130673

ISBN: 1-881450-16-3

CONTENTS

ACKNOWLEDGMENTS

This exhibition would not have been possible without the incredible generosity and support of the artists. The exhibition staff and I thank Brice Marden, Michael Mazur, and Pat Steir for bringing their art into the world and for their patience as we worked on this catalogue and exhibition. We are also grateful to their assistants: Tina Hejtmanek, Max Goldfarb, and Dana Carlson at Brice Marden's studio; Amanda Williamson and Simone Manwarring at Pat Steir's studio; and Elizabeth Mooney at Michael Mazur's studio.

In addition, the Boston University Art Gallery is grateful to Professor Katherine T. O'Connor and the Humanities Foundation of the College of Arts and Sciences, and Graduate School, Boston University, for their support of this catalogue.

I wish to acknowledge the long-term aid provided by research assistants Katrina Jones and Denise Kaplan; their perseverance and enthusiastic dedication to this project were essential. Michaela Mohammadi too contributed invaluable assistance. For their participation and insights, I remain grateful to the members of my Spring 1999 curatorship seminar: Todd Bender, Kristin Bierfelt, Catherine Blais, Joanna Cohen, Kristin Dickson, Michelle Finvarb, Olga Gourko, Zenobia Johnson, Daniela Kubes, Jill Madden, Sarah McGaughey, Christina McIntosh, Melinda Oliveri, Nili Schiffman, Wendy Stein, and Jessica Stock. Finally, I would like to thank the staff of the Boston University Art Gallery: Stacey McCarroll, Curator; Chris Newth, Acting Assistant Director; Evelyn Cohen, Danielle Cabot, Carol Dienstmann, Ryan Evans, Rachel Hyman, Denise Kaplan, Jennifer Joyce, Stephanie Mayer, Jerry Reilly, Gillian Spencer, Catherine Walsh, William Augustus, Marc Mitchell, Jon Payne, and Aaron Sinift. I also thank Vincent Marassa, whose installation expertise made an invaluable contribution to our exhibition.

John Stomberg, *Director* and *Exhibition Curator*

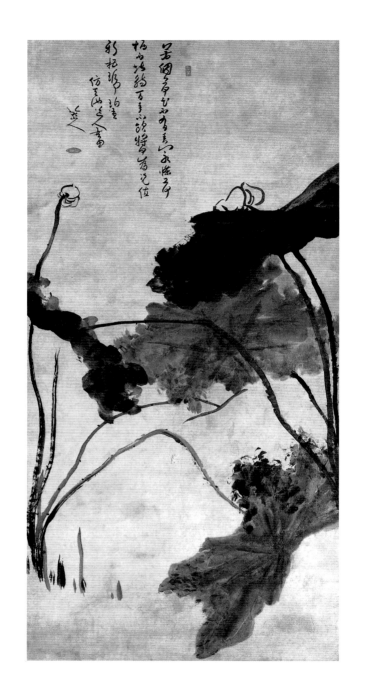

RE-ORIENTING MODERNISM:
BRICE MARDEN, MICHAEL MAZUR, PAT STEIR

Introduction: Parallels and Divergences

Since the third quarter of the nineteenth century, successive waves of artists have sought the future of Western art in the Far East. Early on, the focus was Japan, but through the twentieth century many turned also to China. This exhibition focuses on three contemporary painters who have found profound inspiration in Chinese art. Brice Marden, Michael Mazur, and Pat Steir have engaged in passionate relationships with various art forms from China and responded quite differently in their paintings. Each began their shift into Chinese-inspired art in the late 1980s with a period of creating the images most directly related to their respective sources. Within a decade they were all taking their work in new directions, creating unmistakably Western paintings while maintaining strong visual and philosophical ties to the art of China. The successful hybridization of East and West witnessed in the work of these three artists has considerably extended the life of modernism by reemphasizing its latent Asian component.

Marden, Mazur, and Steir form a tight sampling from which we may infer a shift more widespread than singular in contemporary art. Fiercely individual, these three do share significant biographical relations when seen in a historical perspective. Both Marden (b. 1938, Bronxville, N.Y.) and Steir (b. 1940, Newark, N.J.) attended the Boston University School of Fine and Applied Arts in the late 1950s and there began a strong friendship that continues today. At this time Mazur (b. 1935, New York, N.Y.) was finishing his B.A. at Amherst College (1958) and his B.F.A. from Yale University's School of Art and Architecture (1959). Steir transferred to the Pratt Institute, receiving her B.F.A. in 1962. Mazur stayed on at Yale and received his M.F.A. in the spring of 1961. That fall Marden entered Yale, earning

Frontispiece
Zhu Da
Lotus: Homage to Xu Wei,
1689–1690
Hanging scroll; ink on paper
72 13/16 x 35 3/8 inches
Museum of Fine Arts, Boston

his M.F.A. in 1963. Mazur, after living in Providence, Boston, and New York, settled in the Boston area by the early 1970s; Marden and Steir gravitated early to New York, where each still maintains a primary residence. This is an exhibition, then, that features three artists who were born in the greater New York area within the span of five years; who studied at many of the same art schools at approximately the same times (all of which are located along a narrow stretch of the northeast corridor of the United States); and who shared an artistic development shaped in part through their intimate knowledge of the collections in Boston and New York museums (frontispiece).

Despite these similarities in their backgrounds, Marden, Mazur, and Steir chose entirely different paths for their art. By the time Marden completed his studies at Yale, he had committed himself to a strictly limited range of color (essentially gray) and forms (the rectangle of the canvas). These "Spartan limitations," as he referred to his self-imposed artistic code of conduct, was initially associated with the reductivist activities of the minimalists. His canvases were covered with a mostly undifferentiated monochrome built up from layers of oil paint and wax. Time has shown that Marden's austerity of means provided him with great expressive possibilities, an opening up rather than a closing down. Marden's artistic evolution took him in directions far from the formalist restrictions of minimalism, but never into the realm of naturalism or figurative art.

Mazur, on the other hand, emerged from Yale dedicated to a form of humanist expressionism and then increasingly to Realism. During the decades immediately following school, his art combined the expressive lessons of his teacher Rico LeBrun with the

tradition of social concern that traces to Courbet. His work, especially in the early 1970s, extended much of the theoretical framework for Realism. He was deeply engaged with the reinvigoration of figurative art in the context of late modernism. He worked extensively with prints as well, exploring the dialectics ignited by the trope of "touch" in Abstract Expressionism in the context of mechanical reproduction. To this end, he made monumental monoprints that problematize his relationship to his work, simultaneously indexing the artist's touch and removing it. His printed paintings explore as well the role of image in art; he often used multiple images within each painting, some of which were repeats or ghosts of images that appear elsewhere in the work. Mazur visually quotes himself and openly engages in a discussion on the traffic in images inherent in art—even when these images are self-generated.

Steir's earliest work led her in altogether different directions. Neither the evocations of minimalist art found in Marden's abstractions nor the realism of Mazur's art offered Steir the combination of intellectual complexity and autobiographical searching that she desired for her work. Her earliest paintings knowingly combine the examples of her teachers, Philip Guston (still an Abstract Expressionist at the time) and Richard Linder. As her work developed, she evolved a style of painting that helped define postmodernism. Steir created paintings that undermined their own authority as images. Often including color and gray scales, graphs, numerals, and notations, her paintings bear some relation to her work in the publishing world as well. (Earlier in her career she worked as a book designer

and art director for publishers in New York.) Steir's art was deeply engaged with art history, not simply at the level of pastiche, though this too interested her, but in searching for deeper significances of past art that could be brought to bear on contemporary life.

Were we to have held an exhibition that featured these three artists in 1980, we would have found few connections. Each of them was a firmly established artist; they exhibited regularly and were recognized for, and by, their respective styles—styles that each artist would jettison by the end of the decade. They have each described, in different terms, a visual crisis of faith that gripped them during this time. In 1980 Steir began studying Japanese art and found great inspiration there. At first, Asian art appeared as part of the world art history that she so often quoted in her work. As the decade progressed and her engagement with Asian art deepened, her focus shifted to Chinese art. Marden visited Thailand in 1983, a trip that sparked his interest in Asian art. Seeing an exhibition of Japanese calligraphy the following year propelled his art in entirely new directions. Mazur visited China in 1987. Though the impact of the visit would not be felt in his art for a few years to come, he, too, completely reconfigured his thinking about artistic practice and the lingering potential for modern art in the late twentieth century.

Chinese art, though always a constituent of the modernist domain, remained one of its least utilized resources. In turn, Steir, Marden, and Mazur realized the mistake of that neglect and rediscovered the Chinese influence that lay dormant. Engaged at several key junctures in the evolution of modern art, the potential of Asian art in general had yet to be

fully exploited. These artists were to demonstrate the life that remained in modernism; they revealed a powerful light that has extended considerably modernism's twilight in late modernism by reaching back to the incomplete project of Abstract Expressionism and tapping once again the original Asian sources, especially the woefully underdeveloped opportunities presented through the close study of Chinese art.[1]

Alice Yang writes that generations of modernist critics have looked briefly at Chinese art and distanced the practice through the trope of the Other, whereby "conflicting cultural values are neutralized under the accord of aesthetics."[2] She proceeds to chronicle the list of Western critics who have addressed the Chinese component in modern art and argues that their analysis is mostly reduced to formal universals that strip the art of its greater significance. She contends that the process of translation into the language of global formalism eviscerated the work and obstructed better understanding of the work. While, as Yang notes, it never has received the same attention as "its African or Japanese counterpart, Chinese art has also played a role, albeit intermittent, in the discourse of modern Western art."[3] She discusses essays by Roger Fry, Clement Greenberg, Arthur C. Danto, and Norman Bryson, among others, and concludes, somewhat pessimistically, that

> …the discourse of Western modernism has continually framed Chinese art in relation to its own crisis of representation. This tendency has, in turn, engendered another problem—the problem of representing Chinese art itself in Western criticism. How do we reframe this representation in ways that do not position Chinese art merely as the antithesis or as the analogue of Western art?[4]

1 Their very scholarship sets these artists in a tradition akin to that of Chinese artists. As Michael Sullivan explains, since the eighth century in China painters were considered foremost as scholars, and painting, along with calligraphy and poetry, was their avocation. Michael Sullivan, *Chinese Landscape Painting in the Sui and T'ang Dynasties* (Berkeley: University of California Press, 1980), 14.

2 Alice Yang (1996), "Modernism and the Chinese Other in Twentieth-Century Art Criticism," in *Alice Yang, Why Asia? Contemporary Asian and Asian American Art,* Jonathan Hay and Mimi Young, eds. (New York: New York University Press, 1998), 129. Published posthumously, the title for this essay was provided by the editors.

3 Yang, "Modernism and the Chinese Other," 130.

4 Ibid., 146.

In order to understand the hybrid nature of the paintings in this exhibition, it is necessary to attempt seeing Chinese art and Western modernist art on their own terms. Yang is correct; we cannot construe Chinese art simply as Other, part of the long menu from which Western artists continually order exotic trimmings for their work, and yet hope to find any clarity in our conception of that art.

Marden, Mazur, and Steir attempt to learn the conditions of Chinese art practice before searching for relevant connections to their own art. This approach is closer to the view offered by Geri DePaoli and Gail Gelburd, who see in modern art an attempt not to make art that looks Asian, but that emerges from "the power that conceived the aesthetics."[5] DePaoli and Gelburd express their skepticism in modernist criticism to explain the legacy of Asian influences in American art. They recognize that "from the beginning of the [twentieth] century Asian forms and ideas have gradually been assimilated into American culture and have made up the fiber of a transparent thread" woven through, and therefore inherent to that culture.[6] Where many of the critics and artists whom these authors discuss may have failed, Marden, Mazur, and Steir have succeeded. They have studied Chinese art closely, but they have not copied its forms directly. Instead, they have created a fundamentally new art based on translating Asian aesthetics into a Western dialect. Now critics must follow the artists' lead and reconsider the criteria by which we understand modernism, Asian art, and the history they have shared ever since the cultural cross-pollination between East and West began to accelerate in the late nineteenth century.

5 Geri DePaoli and Gail Gelburd, "Introduction," in *The Trans Parent Thread: Asian Philosophy in Recent American Art* (Hempstead, NY: Hofstra University and Annandale-on-Hudson: Bard College, 1990), 9. Thank you to Catherine Blais for bringing this essay to my attention.

6 Geri DePaoli, "Meditations and Humor: Art as Koan," in DePaoli and Gelburd, *The Trans Parent Thread*, 14.

Not either/or, but both/and: The Asian Aesthetic Presence Within Modernism

The early history of the United States is dominated by attempts to define and redefine its relationship to Europe. Generations of Americans worked to plant an outpost of Western European society in the New World. Americans looked too to expand the legacy of Western civilization. Many articulated the idea of the Westward Course of Empire: the civilization that was born in Greece and then moved into Europe had immigrated to America, where the next chapter in the history of Western civilization would be written. As the nineteenth century progressed, the western frontier was closed, and the once-boundless nation had achieved its "manifest destiny" by expanding as far west as its natural boundaries would allow. At that point, late in the century, artists began to look beyond the West for inspiration, an idea that, like so many others at the time, stemmed from Paris.

At first the Eastern influence in European art was manifested as an infatuation with Japanese material culture. Painters who shared this enthusiasm, which earned the epithet *Japonisme* at the time, typically demonstrated their passion through the inclusion of a number of strategically placed objects in their painted interiors.[7] Though a volume of Hokusai's woodblock prints was known in Paris in 1856, the first glimpse of Japanese decorative arts for most of these artists came at the world expositions of the 1860s.[8] Japanese society had been largely cut off from the West for most of the two centuries prior to London's World Exposition of 1862. The London Exposition featured an entire courtyard containing a wide array of handcrafted objects from Japan. Many

7 Helen Westgeest, *Zen in the Fifties: Interaction in Art Between East and West* (Zwolle: Waanders Uitgevers; Amstelveen: Cobra Museum voor Moderne Kunst, 1996), 29. According to G. P. Weisberg, the term *"Japonisme"* was coined by French critic Philippe Burty. See G. P. Weisberg, *Japonisme: Japanese Influence on French Art* (Cleveland: Cleveland Museum of Art, 1975), 15.

8 Benjamin Rowland Jr., *Art in East and West: An Introduction Through Comparisons* (Cambridge: Harvard University Press, 1954), 91. In 1862 a shop dedicated to the sale of Japanese goods opened for business in Paris as well.

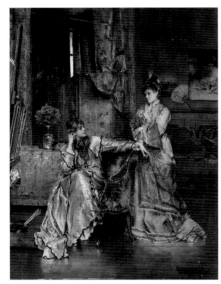

Figure 1
Alfred Stevens
The Visit, c. 1867
Oil on panel
25 3/8 x 16 9/16 inches
Sterling and Francine
Clark Art Institute

9 For more on Stevens, see William Coles,
 Alfred Stevens (Ann Arbor: University of
 Michigan Museum of Art, 1977).

wealthy Europeans began avidly collecting Japanese items such as porcelain, fans, and kimonos. These objects became emblems of high culture. By the time of the Paris World Exposition in 1867, Japanese material culture appeared in fashionable portraiture as testaments to the sitters' cultural status. Such emblematic uses of Japanese objects are exemplified in paintings such as Alfred Stevens's *The Visit,* which was displayed at the 1867 Paris Exposition (fig. 1).[9] In the case of the Stevens painting, the attraction to Far Eastern culture remains cosmetic. The painting reflects little interest in, or study of, Japanese pictorial composition or the underlying philosophies from which it was inspired. The painting remains essentially Western, demonstrating an approach to structuring an image that originates in the Renaissance.

For more progressive artists, the period of *Japonisme* provided an entirely new approach to depiction, as well as adding prop possibilities for their interior scenes. Impressionist artists, including Auguste Renoir and Claude Monet, painted women dressed in Japanese kimonos occupying rooms brimming with decorative objects from the Far East. These artists displayed an attraction for the surface enticements of these objects as well as a growing appreciation for the formal lessons gleaned from the study of Japanese prints. From the 1860s, prints from Japan were readily available in major cities such as London, Paris, and New York.

Vincent van Gogh's art betrayed a deep affinity for Japanese prints; he had encountered them early in his career—while he was still in Antwerp—and had them hanging on the wall of his studio.[10] Van Gogh's painted copies of Hiroshige prints moved *Japonisme* beyond its period of infatuation and into a more profound engagement with Asian art (fig. 2). Meyer Shapiro explains that van Gogh's attraction to Japanese art was a form of liberation: "By admitting the foreign creations to the highest status of art, the closed tradition is opened and the individual is freed from the constraint of local precedent."[11] Van Gogh's paintings possess both the look and formal construction of the Hiroshige prints, but the surfaces, the paint handling, and the colors belong to his expressive style. For artists in the first wave of *Japonisme,* such as Stevens, the Japanese influence was one of affectation. Van Gogh internalized the lessons encoded in Hiroshige's prints—the results of centuries of subtle refinement—and they become part of his modernist enterprise.

In 1863, one year after the London World Exposition, the American expatriate painter James Abbot McNeill Whistler—then living in London—began to collect Japanese woodblock prints *(Ukiyo-e)* as well as decorative arts. His study of these items would change his art permanently. In his paintings of the 1860s, he too used objects of Asian origin largely as visual accoutrements, but during a trip to Chile he began to incorporate "Oriental

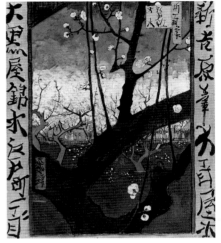

Figure 2
Vincent van Gogh
*Japonaiserie: The Flowering
Plum Tree (after Hiroshige),* 1887
Oil on canvas
55 x 46 cm.
Rijkmuseum Vincent van Gogh,
Amsterdam

10 Meyer Shapiro, *Vincent van Gogh* (New York: Harry N. Abrams, 1983), 16.

11 Ibid., 18.

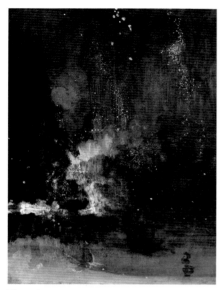

Figure 3
James Abbot McNeill Whistler
*Nocturne in Black and Gold,
the Falling Rocket,* c. 1875
Oil on oak panel
23 45/64 x 18 3/8 inches
Detroit Institute of Arts

compositional devices into the actual structure of his view of the harbor at Valparaiso."[12] During this trip Whistler created an evening view of the harbor that would act as the basis for all his later "Nocturnes." In *Nocturne in Black and Gold, the Falling Rocket,* for example, he uses a softly modulated, harmonious tonal range of color specifically intended to evoke those used in Chinese painting (fig. 3). He made manifest the idea that color carried within it latent emotive qualities that could be made to work in concert with forms to create works of understated force. In the even modulations of grays and blues, activated sporadically by the gold spatters of paint that represent sparks descending from an exhausted fireworks rocket, Whistler achieved a break from the Western art of his past and embraced the Eastern influence that he would help inject into the mainstream of modernism.

Whistler's passion for Asian art also contributed greatly to the American understanding of what were then obscure and rare forms of aesthetic endeavors through his connection to and influence upon the collector Charles Lang Freer, founder of the Freer Gallery of Art in Washington, D.C. In addition to amassing the definitive collection of Whistler's art—along with that of other Tonalist artists—Freer sought out the artist's advice in building a collection of Asian art that would accentuate and complement the American paintings.

As the press release announcing the plans for the museum noted, "Chinese and Japanese art are singular in their character and harmonize with the work of Whistler, Dewing, Tryon, and Thayer...."[13] When the Freer Gallery opened to the public in 1923, it made patently obvious the connections between Asian aesthetics and the development of modern art.

In addition to Whistler, Freer counted on the advice of Ernest Fenollosa to guide his acquisitions of Asian art. Fenollosa, a professor and curator whose expertise lay in Japanese art, was key in supporting the possibility of hybridization between Eastern and Western aesthetics in the United States.[14] He greatly admired Whistler's art, noting that the artist "was led by Japanese art much further—not only through a strengthening to solve problems already conceived, but through a suggestion of new ranges of aesthetic quality, utterly strange species of beauty, that had never been suspected, or at least fully stated, in earlier Western art."[15] Fenollosa saw in Whistler an affirmation of his hopes for the unity of "Oriental" and "Occidental" aesthetics. He emphasized that the artist was creating something new, not copying or diluting Chinese and Japanese art, but fusing his deep study of those modes of composition with a Western sensibility to initiate a heretofore unseen and "utterly strange species of beauty."

12 David Park Curry, *James McNeill Whistler at the Freer Gallery of Art* (Washington, DC: Freer Gallery of Art, Smithsonian Institution, 1984), 119.

13 "Facts Concerning the Freer Art Collection," *Washington Star,* 11 March 1906, 10, cited in Curry, *James McNeill Whistler,* 16–17, n. 27.

14 Lawrence W. Chisolm, *Fenollosa: The Far East and American Culture* (Westport, CT: Greenwood Press, 1976).

15 Ernest Fenollosa, "The Collection of Mr. Charles L. Freer," *Pacific Era* 1 (November 1907): 60, cited in ibid., 17.

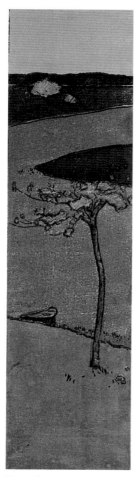

Figure 4
Arthur Wesley Dow
Bend in a River, 1895
Color woodcut
7 3/16 x 2 7/8 inches
Herbert F. Johnson
Museum of Art,
Cornell University

Fenollosa contributed greatly to the creation of this new field of aesthetic opportunity. He was the curator responsible for the development of the great collection of Japanese and Chinese art at the Museum of Fine Arts, Boston. In addition, he wrote avidly about the young artists who were creating works in the innovative style that he was having a hand in fostering.[16] One of these artists was Arthur Wesley Dow, who met Fenollosa soon after returning from Paris in 1889. The young Dow found in Japanese art, particularly in the prints of Hokusai Katsushika (1760–1849) a new path for his own work. In a letter to his wife, he claimed that "One evening with Hokusai gave me more light on composition and decorative effect than years of the study of pictures. I surely ought to compose in an entirely different manner and paint better."[17] In 1895 Dow completed a series of prints that reflect his interest in Japanese aesthetics (fig. 4). They are characterized by their generalizing of forms and localized colors. Fenollosa exhibited Dow's prints in an area of the Boston Museum of Fine Arts normally occupied by Japanese art.[18] This exhibition established the young artist's reputation within a limited though influential audience in New England.

Dow's proselytizing reached an even wider audience through his teaching and writing. Starting in the summer of 1891 he ran the Ipswich Summer School of Art in the small Massachusetts coastal town for which the school was named. In 1895 he moved to New York to start teaching at the Pratt Institute, then in Brooklyn, and in 1904 he began his career as the head of the Art Department at Teachers College Columbia University.[19]

Also, his books helped enable his students to carry Dow's lessons with them to artistic centers around the country. Many of these students in turn became teachers who used Dow's books to teach a new generation the ideas that Dow had developed with the guidance of Fenollosa.[20] Dow's influence on American modernism is difficult to gauge. So many of his students went on to have illustrious careers as teachers around the country that his aesthetic ideas were filtered down to following generations. We can with reasonable certitude assert that he made a major contribution to the receptivity that Asian aesthetics met in the United States and that this openness in turn has been key in the evolution of domestic modernism.[21]

One of Dow's students, Georgia O'Keeffe, was a young art teacher who found a great deal of symbiosis between her own work and his teachings. O'Keeffe had been exposed to Dow's teachings through Alon Bement, her teacher at the University of Virginia in 1912.[22] Two years later she enrolled in Dow's class at Columbia University, returning to New York where she had been a student at the Art Students League in 1908. O'Keeffe's early paintings directly reflect Dow's influence in the austerity of their formal means (fig. 5). She had read Fenollosa's book, *Epochs of Chinese and Japanese Art,* and some of her 1916 drawings were overtly inspired by the *Sumi-e* brush technique in Japanese art. It was this work that attracted the attention of Alfred Stieglitz, whose 291 Gallery O'Keeffe had frequented when she was in New York. Introduced by a mutual friend, Stieglitz and

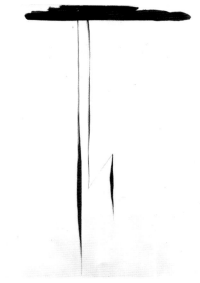

Figure 5
Georgia O'Keeffe
Blue Lines, No. 10, 1916
Watercolor on paper
24 9/10 x 18 9/10 inches
The Metropolitan Museum of Art,
New York

16 It must be noted that Fenollosa had a col-
 league on the west coast, Henry P. Bowie,
 whose influence in the San Francisco area
 paralleled to some extent Fenollosa's on the
 east coast. See, for example, his book: Henry
 P. Bowie, *On the Laws of Japanese Painting*
 [1911] (New York: Dover Publications, 1958).

17 Arthur Wesley Dow, letter to Minnie Dow, 26
 February 1890, cited in Nancy Green, "Arthur
 Wesley Dow, Artist and Educator," in Nancy
 Green and Jessie Poesch, *Arthur Wesley
 Dow and American Arts and Crafts* (New
 York: Harry N. Abrams, 1999), 61, n. 10.

18 Green, "Arthur Wesley Dow, Artist and
 Educator," 63.

19 Ibid., 67.

20 Arthur Wesley Dow, *Composition: A Series of
 Exercises in Art Structure for the Use of
 Students and Teacher* (1899), reprint, intro. by
 Joseph Masheck (Berkeley: University of
 California Press, 1997); Arthur Wesley Dow,
 Theory and Practice of Teaching Art (New
 York: Teachers College Columbia University,
 1908).

21 Dow was also responsible for hiring Clarence
 White to teach at Teachers College and through
 him inspired generations of photographers
 such as Margaret Bourke-White (who also
 studied directly with Dow) and Ralph Steiner.

22 Charles Eldredge, *Georgia O'Keeffe:
 American and Modern* (New Haven: Yale
 University Press, 1993), 20.

23 Sarah Whitaker Peters, *Becoming O'Keeffe:
 The Early Years* (New York: Abbeville Press,
 1991), 81–100.

24 Eliza E. Rathbone, *Mark Tobey: City Paintings*
 (Washington, DC: National Gallery of Art,
 1984), 22.

25 William Seitz, *Mark Tobey* (New York:
 Museum of Modern Art, 1962), 9–18.

O'Keeffe began a correspondence that led to her first solo exhibition at Stieglitz's gallery. O'Keeffe's legendary career owed much to Dow's lessons. Though her work eventually moved in directions in which the Asian influence is difficult to discern, her contributions to American modern art are well documented and her study with Dow in New York had much to do with the original trajectory of her career.[23] O'Keeffe's exhibitions at Alfred Stieglitz's 291 Gallery, and at An American Place, helped disseminate Dow's teachings, even as these lessons had become filtered through her own emergent style of American modernism.

Mark Tobey, who had moved to New York before World War I (1911) to work as an illustrator, found in O'Keeffe's works a fresh approach to the landscape in particular—an interest that would mark the beginning of his career-long study of Oriental art.[24] As a young man Tobey converted to the Bahá'í World Faith, an act that he felt provided the single greatest biographical fact necessary for the comprehension of his goals for art. It is a faith of universality, one that combines religion (all religion) and science into a synthetic, all-encompassing, and spiritual worldview.[25] His faith convinced Tobey of the appropriateness of creating art that sought to evoke spirituality indirectly, abstractly.

In 1922, Tobey moved west to Seattle to accept a teaching job, beginning a lifelong association with that city. He would, along with Morris Graves, Keneth Callahan, and Guy Anderson, represent the nucleus of what *Life* magazine called the "Mystic Painters of the Northwest," who were characterized by their "mystical feeling toward life and the

universe, their awareness of the overwhelming forces of nature and the influence of the

Orient."[26] In Seattle, Tobey trained with a Chinese calligrapher who was in the country at

the time studying at the University of Washington. This was a pursuit greatly encouraged

by his transfer to Dartington Hall, an art school in England, where he taught from 1932 to

1938. There he met many of the leading cultural thinkers of the day, including Aldous

Huxley and Arthur Waley, both of whom were dedicated, like Fenollosa, to the idea of

merging Eastern and Western culture. Dartington supported his travel to China (by helping

him secure funding), where he stayed with the family of his calligrapher friend from

Seattle. He also spent a month in a Zen monastery in Kyoto. His art is infused heavily by

his experiences in China and Japan, especially his training in calligraphy and *Sumi-e*

techniques, but, as he says of himself, "I could never be anything but the occidental

that I am."[27]

In his paintings Tobey knowingly fuses Western modernism with an Eastern philo-

sophy of art (fig. 6). His works are not calligraphic in the Japanese or Chinese sense, yet

they depend greatly on time spent learning how to form characters with brush and ink. He

creates an obscure—in fact, inscrutable—vocabulary of mythic characters that interact

with areas of color. In this way he evokes oblique suggestions of place or time, but only

those of the painting itself. This non-referentiality makes his work essentially Western,

yet his process for arriving at his aesthetics is largely Eastern—an evolution he shares with

Figure 6
Mark Tobey
New York, 1944
Tempera on paperboard
33 x 21 inches
National Gallery of Art,
Washington

26 "Mystic Painters of the Northwest," Life, 27
 April 1953, 84, quoted in Rathbone, *Mark
 Tobey*, 17.
27 Mark Tobey, quoted in Seitz, *Mark Tobey*, 50.

Marden in particular, but also Steir and Mazur. His goal was to achieve something of the power of Japanese art in a decidedly Western idiom, to match what he described as the "awareness to nature and everything she manifests, which seems to characterize the Japanese spirit. An awareness of the smallest detail of her vastness as though the whole were contained therein and that from a leaf, an insect, a universe appeared."[28] Tobey too attempted to make each painting a universe unto its own with a pictorial language native to that painting. Modernism reigned in Tobey's paintings, but his work also exemplified the extent to which his contact with Asian visual culture helped to shape and direct his work— an impact that in turn became part of modernism's progressive refinement.

When asked for his assessment of contemporary painting in 1947, the influential critic Clement Greenberg wrote, "The two most original American painters today, in the sense of being the most uniquely and differentiatedly American, are Morris Graves and Mark Tobey, both products of the Klee school, both somewhat under the influence of Oriental art, as Klee himself was, and both from Seattle in the Northwest."[29] It is worth noting here that Greenberg describes the artists as "somewhat under the influence of" the Oriental aspect, while the Klee connection is portrayed in much stronger terms. For both artists, the connection to Eastern art was profound, as it was for Klee, suggesting that even their participation in the "Klee school" was actually motivated by the connections to the spirit of Chinese and Japanese art.

28 Mark Tobey, unpublished travel notes, quoted in Rathbone, *Mark Tobey,* 25.

29 Clement Greenberg, "The Present Prospects of American Painting and Sculpture," *Horizon* 16 (October 1947): 25–26, quoted in Judith S. Kays, "Mark Tobey and Jackson Pollock," in *Mark Tobey* (Madrid: Museo Nacional Centro de Arte Reina Sofia, 1997), 105.

Tobey's friend and colleague, Morris Graves, nurtured an understanding of Asian art that, as it did for Tobey, informed his work throughout his life. He too journeyed to the Orient as a young man, traveling as a merchant marine in 1928. Graves spent his leave time at ports in Japan and China collecting artifacts. He returned on two occasions in 1930 as well, trips that allowed him further opportunity to study the art and philosophy of both countries. Upon his return to the Seattle area, he began visiting a local Buddhist temple and through his contacts there gained exposure to both Zen teachings and to writings—including those by Fenollosa—on the sort of Asian art he studied during his journeys.

In his paintings Graves knowingly attempts to evoke a spiritual connectivity with nature that he first discovered in Asian art (fig. 7). He once wrote,

> The artists of Asia have spiritually-realized form, rather than aesthetically-invented or imitated form, and from them I have learned that art and nature are mind's environment within which we can detect the essence of man's Being and Purpose, and from which we can draw clues to guide our journey from partial consciousness to full consciousness.[30]

Graves met John Cage in 1937 when the latter moved to Seattle to find work. Their friendship and mutual interest in Zen continued through their various moves—primarily to New York. As Ray Kass has pointed out, Dada and Zen merged in the early works of both artists. In the early 1940s, and after much prompting from friends, Graves began to exhibit in New York and became something of an honorary member of the New York School. The Marian Willard Gallery began representing him in 1940, and the Museum of Modern Art exhibited thirty of Graves's works in *Americans 1942: 18 Artists from 9 States*.[31]

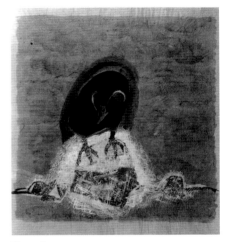

Figure 7
Morris Graves
Blind Bird, 1940
Gouache and watercolor on mulberry paper
30 1/8 x 27 inches (irreg.)
The Museum of Modern Art,
New York

30 Morris Graves, Guggenheim Fellowship application, 1945, quoted in Ray Kass, *Morrris Graves: Vision of the Inner Eye* (New York: George Braziller, Inc., 1983), 31.

31 Ibid. See also George M. Cohen, "The Bird Paintings of Morris Graves," *College Art Journal* 18 (Fall 1958): 2–19.

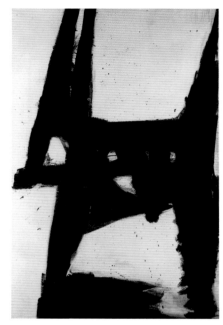

Figure 8
Franz Kline
Four Square, 1956
Oil on canvas
78 3/8 x 50 3/4 inches
National Gallery of Art,
Washington

Graves's work, when it was exhibited in New York, helped fuel a surge of interest in Zen that was already gaining momentum in New York, and like so many other artists, his work knowingly attempted to evoke Asian art, but remained essentially Western in its formal characteristics. As Benjamin Rowland noted in the 1950s, many writers talked about Graves's "calligraphic" brushwork, which, the author explains, "as used by Western art critics signifies a recognized pattern or structure in the individual lines comprising a picture and something like the flourish or movement of brushstrokes that is supposed to be comparable to Oriental painting."[32] And, he points out, despite Graves's study of Eastern art, his work was "only superficially related to the Chinese and Japanese tradition of painting."[33] This was typical of the relationship between New York School painting and Zen. Eastern philosophy was undoubtedly part of the heady mix that informed Abstract Expressionism, but we cannot determine that there are necessarily overt formal connections between Chinese painting or calligraphy and American abstract painting in the post–World War II era.

We can find many specific examples of artists of the period working to situate themselves in relation to Zen and Asian aesthetics. This was, perhaps, more important to Franz Kline than anyone else at the time, due to the seeming connections between his paintings and calligraphy (fig. 8). Kline attempted throughout his career to distance his work from the obvious connections to Chinese art; he felt it was detrimental to a deeper understanding of his work.[34] In point of fact, his work has little of the aesthetic of Chinese calligraphy

involved. He built up his surfaces slowly, deliberately, and overlapped layers of paints; there is little of the decisive gesture so valued in *Sumi-e*. He did create images and compositions that echo Asian painting and emphasized the white background as a positive presence in his paintings, not as the space in which the black characters existed.

Kline needed to distance himself from Zen and Asian aesthetics to avoid becoming pigeonholed as an artist who simply created monumental-sized calligraphy, but there is in his work a betrayal of close study of Asian art. Critics too obligingly made much of the differences and downplayed any similarities to Asian art. Though in the United States Kline was constantly at pains to explain away any relationship to non-Western art, in Japan he openly acknowledged the connection.[35] In the early 1930s Kline lived in Boston for the better part of four years.[36] During that time, as Ryan Holmberg has shown in his research, Kline embarked on a self-study of Chinese and Japanese art. Kline wrote of that time, in a letter published in a Japanese art periodical in 1951,

> It was when I saw the works of Kōrin, Sesshū, and Hokusai at the Boston Museum of Fine Arts. They made an extremely strong impression on me in my student years. With the exception of Rembrandt, whom I had been studying for many years, my love of Kōrin, Hokusai, and earlier Chinese and Japanese painters became increasingly strong after this experience.[37]

Kline, then, spent his student years learning from the same collections that had so enthralled Dow before him and that would in future decades captivate all three of the artists in this exhibition.

32 Rowland, *Art in East and West,* 126.

33 Ibid.

34 Harry F. Gaugh, *The Vital Gesture: Franz Kline* (Cincinnati: Cincinnati Art Museum, 1985), 18.

35 Ryan Holmberg, "Dragon Knows Dragon: The Encounter between Japanese Avant-Garde Calligraphy and Abstract Expressionism," unpublished Independent Work for Distinction in Art History, Boston University, 1998, 66.

36 For one year Kline attended Boston University where he majored in psychology and then studied at the Boston Art Students League. He remained from 1931 to 1935. Gaugh, *The Vital Gesture,* 176.

37 Franz Kline, *"Franz Kline-shi ryakurei—Dōshi yori Hasegawa-shi-ate no tegami,"* (A Short Biography of Franz Kline and a letter to Hasegawa), trans. Ryan Holmberg, in *Bokubi* 1 (June 1951), np, quoted in Holmberg, "Dragon Knows Dragon," 68–69.

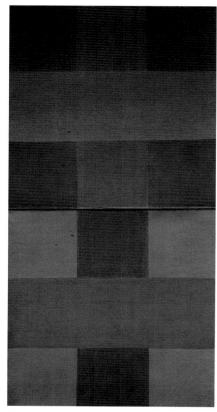

Figure 9
Ad Reinhardt
Abstract Painting, Red, 1952
Oil on canvas
30 x 15 inches
Collection of Whitney Museum
of American Art, New York

While interest in Asian aesthetics receives frequent mention in the literature on the art of the 1940s and 1950s, the degree of engagement that these different artists had remains murky. Many discussed reading the works of D. T. Suzuki and Arthur Waley, for example, but exactly where or how that study appears in their work remains understudied.[38] These authors offered broad recommendations for American artists interested in Zen. Suzuki, for example, wrote that the artist "creates forms and sounds out of formlessness and soundlessness. To this extent, the artist's world coincides with that of Zen."[39] For many painters in this period, a study of Zen became an important part of the quest for a vanguard style. Philip Guston told David Clarke, "Let me say that since 1948 up until now [1979], and more than ever—my reading of Zen has been intense. The ideas as expressed by Suzuki have always been an ideal for me in painting."[40] Other artists of the period also had complex relationships to Zen and Eastern aesthetics. (These themes are taken up in more detail in Catherine L. Blais's essay on the "Zenboom" included in this volume.)

Ad Reinhardt, for example, was deeply interested in Asian art and taught art history courses on the subject.[41] He also discussed Suzuki and Waley, citing their works as important for his art (fig. 9).[42] But was his art Zen-influenced simply because of these interests? There are examples in his work that suggest these connections such as the *Chinese Verticals* series, so-called for their visual similarities to Chinese landscape paintings.[43] Helen Westgeest suggests too that the anonymity of his late works, especially his "Black" paintings, derive their spiritual power from the artist's close study of Zen.[44] Reinhardt's

aesthetic theories are numerous and varied, but are often directly informed by Zen—the simple praise of negative spaces thought of as positive presences is derived from a study of Asian art and philosophy. But Reinhardt's ideas deliberately confound categorization and his paintings, quiet and conducive to contemplation, defy simple alliances with either Asian art or Abstract Expressionism.

These artists who borrowed directly and indirectly from Chinese or Japanese art, including calligraphy, shaped much of what we recognize as the New York School in painting of the 1940s and 1950s. Echoes of Eastern aesthetics and thought permeate the art of gestural artists of the period who were concerned with the potency of touch in their mark-making, such as Tobey and Kline. These ideas also offered guidance to Reinhardt, who created geometrically driven, subtle abstractions that reflected contemplation of the potential for a harmonious universe. This meditative quality lived on into the 1960s and 1970s through the work of Agnes Martin, whose paintings differ greatly from Reinhardt's, but emerge from a similar interest in contemplating a world of spiritual harmony.

Martin's philosophy merged the heavy doses of Biblical teachings she received as a child with her own exposure to Zen and Daoism (Taoism). Her paintings reflect a slow, deliberate process that evokes the tradition of monastic scribes and illuminators (fig. 10). Barbara Haskell writes, "Only through such pure, egoless abstraction did she feel that the immaterial sublimity of reality could be communicated."[45] Martin came from western Canada, spending most of her youth in Vancouver. She lived in New York intermittently in the 1940s and 1950s, dividing her time between the metropolis and the

Figure 10
Agnes Martin
Milk River, 1963
Oil on canvas
72 x 72 inches
Collection of Whitney Museum
of American Art, New York

38 See Arthur Waley, *Zen Buddhism and Its Relation to Art* (London: Luzac, 1922), and Arthur Waley, *An Introduction to the Study of Chinese Painting* (New York: Charles Scribner's Sons, 1923); Daisetz T. Suzuki, *Essays in Zen Buddhism,* 3 vols. (London, 1927, 1933, 1934).

39 Daisetz T. Suzuki, *Zen and Japanese Culture* (1938), quoted in David J. Clarke, *The Influence of Oriental Thought on Postwar American Painting and Sculpture* (New York: Garland Publishing, 1988), 80.

40 Philip Guston, letter to David Clarke, 20 September 1979, quoted in David Clarke, *The Influence of Oriental Thought on Postwar American Painting and Sculpture* (New York: Garland Publishing, 1988), 82.

41 Westgeest, *Zen in the Fifties,* 67.

42 It should be noted that Reinhardt was committed to reading a wide variety of "religious texts, especially the various mystical, oxymoronic traditions that glorified the night, inverting it into light." Yve-Alain Bois, "The Limit of Almost," in *Ad Reinhardt* (New York: Museum of Modern Art, 1991), 29.

43 See Lucy Lippard, *Ad Reinhardt* (New York: Harry N. Abrams, 1981), 58.

44 Westgeest, *Zen in the Fifties,* 68–71.

45 Barbara Haskell, "Agnes Martin: The Awareness of Perfection," in Barbara Haskell, *Agnes Martin* (New York: Whitney Museum of American Art, 1992), 95.

46 Agnes Martin, quoted in Suzanne Delehanty, Lawrence Alloway, and Ann Wilson, *Agnes Martin* (Philadelphia: Institute of Contemporary Art, University of Pennsylvania, 1973), 32.

47 Agnes Martin, quoted in Haskell, *Agnes Martin,* 95.

American southwest, where she would eventually settle. She was in the city during the years when Suzuki gave regular lectures on Zen at Columbia University (where she was enrolled) and Cage and Reinhardt talked publicly about the Zen influence on their art. The tension between the suggested precision of the grid and the subtle, human variations in the execution of her paintings—combining the ideal with the real—reflect her personal metaphysics of life. A prolific writer as well, Martin says, "I would rather think of humility than anything else."[46] Her philosophies and her art, both stressing what she calls the "positiveness of reality," proved widely inspirational for the generation of artists who, like Martin, looked for ways to infuse painting with enduring metaphysical significance while trying to avoid overt physical manifestations of self in their work.[47]

In various forms, Asian art and ideas became part of the mix as they merged into the projection of new art. While we find many ideas lingering in these artists' statements that reflect a familiarity with Asian aesthetic philosophies, direct visual echoes of Eastern art are rare in the paintings of the period. The transference of culture from one to another inspired art that was completely connected to neither, but had roots in both. This is the legacy we find resurfacing in the work of Marden, Mazur, and Steir, and it is one that finds its beginnings in Steir's crucial 1970 visit to Martin in New Mexico.

Pat Steir: The Nature and Image of Image and Nature

Pat Steir, when asked about the deliberate progression that appears in all of her work, emphasizes that she has always explored freely—"just following [her] inner voice."[48] Though she evokes the irrational side of her decision making, her art has often been praised for the intellectual vigor it reflects. Throughout her career she has critiqued art history, even as she has made art that has participated in new developments in art history. Often considered the quintessential postmodern painter, Steir's career to date has proved far more varied and challenging than pigeonholing her work into narrow style definitions would allow. As Thomas McEvilley, author of the essential critical history on her work, summarizes her career,

> At that moment [late 1950s] Abstract Expressionism did not exert a formative influence on Steir as an artist; she struggled away from it, and, with irony but also with a certain tenderness, her oeuvre would describe a long trajectory away from the milieu of action painting, at the end of which it would find its way back to it, in a redefined form, with certain of the originally unarticulated problems of the Abstract Expressionist ideology resolved, or at least redirected.[49]

Many of her paintings completed prior to the mid 1980s involved the quotation and reformulation of past art that came to define postmodernism. But much of that art and theory was predicated on the rather pessimistic notion that painting could no longer offer the innovations that characterized modernism. It was her search for art from which to borrow that led to her encounter with the art of China, an encounter that profoundly altered her approach to, and belief in, painting.

48 Pat Steir, quoted in Barbara Weidle, "Interview," in John Yau, *Dazzling Water, Dazzling Light* (Seattle: University of Washington Press, 2000), 70.

49 Thomas McEvilley, *Pat Steir* (New York: Abrams Publishers, 1995), 16.

Figure 11

Pat Steir

Cellar Door, 1972

Oil, crayon, pencil, and ink on canvas

72 x 108 inches

Collection of Mr. and Mrs. Robert Kaye, New York

In the years directly after leaving art school, Steir worked on a variety of self-portraits that knowingly examined the new role of self in post–Abstract Expressionist art. These works emerged from the dynamic created by studying with Linder and Guston at Pratt (Guston had yet to start teaching at Boston University when Steir was there). The pull to

figuration met resistance from her attraction to abstraction, and her early self-portraits reflect elements of both efforts simultaneously. This tension between mark as mark and mark as reference to something else—arched brushstroke versus mountain—would dominate her work for the first twenty years of her career.

Some of her earliest works after the self-portraits exposed the enterprise of art-making in richly theorized paintings such as *Cellar Door,* 1972 (fig. 11). At this point she had introduced a lightly drawn grid into her works, partly as an homage to Martin (her 1970 visit to Martin still looming large in her thoughts) and partly to explore the role of the grid in making pictures. Steir carefully depicts much of what was left implicit in Martin's work. This painting includes a history of Western art theory rendered in painted signs. We find the sublimity of Malevich's *Black Square* both carefully inscribed within the grid and overriding it in an extended cascade of pigment suggestive of the waterfalls in ninteenth-century landscape paintings. The landscape tradition is given a conceptual edge with the instructions to walk along the arrows at the ridge of the mountains. The gray scale, rendered arbitrarily in this case, accompanies a vertical expanse of black pigment—it is both ironic and suggestive. If the remainder of the painting is the deconstruction of the process of art-making, then this rectangle is the picture—but it is not a picture. Steir has been attracted to this type of conundrum throughout her career and to the idea of oxymoron: being a thing and its negation at the same time.[50] Her paintings of this period need to be seen and read; understanding them requires an intricate detangling of the reference and the referent.[51]

50 As Bruce W. Ferguson has recently observed, this notion has permeated art practice for years. "An oxymoron," he points out, "acts as a space of limbo or undecideability, a space in which choice is suspended and contrary impulses occupy the same position simultaneously." Much of the work to which Ferguson alludes is no doubt indebted to these earlier works by Steir. Bruce Ferguson, "Postmark: An Abstract Effect," in Bruce W. Ferguson and Louis Grachos, *Postmark: An Abstract Effect* (Santa Fe, NM: SITE Santa Fe, 1999), 11.

51 Steir had a seminal role in the development of semiotics and art. She was deeply involved at the board level of *Heresies* and *Printed Matter* magazines, as well as editor of *Semiotext* in the late 1970s.

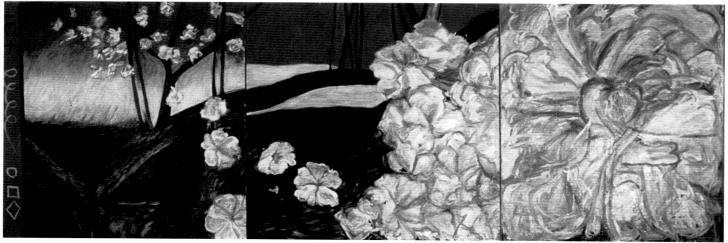

Figure 12
Pat Steir
The Tree, 1982
Oil on canvas
3 panels, overall 60 x 180 inches
Collection of Jean Paul Jungo,
Morges, Switzerland

In the early 1980s, Steir is simultaneously creating her large-scale postmodern works and discovering the art that will soon lead her into an entirely new territory. As part of her ceaseless quest for source material for her paintings, Steir finds interest in the late-ninteenth-century European enthusiasm for Japanese art, especially in the multiplicity of references in *Japonisme.* The hybrid pictures that excite her inspire further hybridization in her own work. At first this appears in works directly evocative of *Japonisme* such as *The Tree,* 1982, a transliteration of van Gogh's translation of an Ando Hiroshige print (fig. 12; see also fig. 2 above). The project offered Steir a chance to increase the level of textual complexity in her work exponentially: Asian source multiplied by European tradition multiplied

by postwar American art. As if to reinforce the magnitude of the outcome, each of the three panels measures five feet square, creating a monumental painting when joined that thoroughly dwarfs the size of the van Gogh and the Hiroshige.

Monumentality always plays an important role in Steir's paintings, but perhaps at no time more than when she created the summation of her postmodern efforts, encapsulating the majority of art history into a single work. *The Brueghel Series (A Vanitas of Style)*, 1982–84, consists of sixty-four panels that assemble to almost twenty by fifteen feet (fig. 13). She painted each panel in the style of a different artist, but the whole image emerges as a version of a still life by Jan Brueghel the Elder. In creating this painting, Steir made art history her own, a tool. She both serves this history and is served by it. This work has become canonical in the study of later twentieth-century art. "I've made my first painting more than once," Steir told Carter Ratcliff. "This was another first painting."[52] It was also a last painting in that it summarized in a grand statement the ideas that had dominated her art practice for the prior decades. "Everything I had done up to this point had been too complicated," she continued. "With *The Brueghel Series* I found a way to make my art clear."[53] In the process of making this work, she began to understand more fully and directly the potential of Asian art and philosophy. She also moved deeper inside the work of abstract artists such as Kline, Rothko, and Pollock. In the process of painting the individual panels for *The Brueghel Series (A Vanitas of Style)*, she came to a remarkable real-

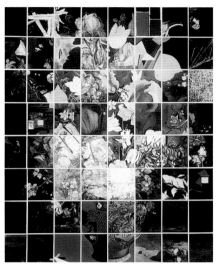

Figure 13
Pat Steir
*The Brueghel Series
(A Vanitas of Style),* 1982–84
Oil on canvas
64 panels,
each 28 1/2 x 22 1/2 inches
Kunstmuseum, Bern

52 Pat Steir, in Carter Ratcliff, *Pat Steir Paintings* (New York: Harry N. Abrams, Inc., 1986), 78.

53 Ibid.

ization: expressive abstraction was not fully exhausted. As if opening a door on a room full of long-forgotten treasures, Steir realized that Abstract Expressionism had not been fully developed—essentially, Andy Warhol jumped the gun.

Steir followed her *Brueghel Series* with a group of paintings, the *Wave Series,* that reassert the self into the process of painting. This series began with *First Wave after Hokusai in Blue,* 1986, a painting that both extends the artist's interest in working through reinterpretation and greatly expands the gestural abstraction that had always operated at the margins of her paintings. We can see the brushstroke-as-mark in her earlier works such as *Cellar Door,* where we find as well the cascading, dripping paint that began to denote a new engagement with process for Steir. In the wave paintings, all of which were variations of Katsushika Hokusai's magisterial print *The Great Wave of Kanagawa,* 1823–29, Steir creates artistic pseudo-formulas for the creation of her paintings—for example, *Autumn: The Wave after Courbet as though Painted by Turner with the Chinese in Mind,* 1985. Though a continuation of her earlier concerns for the semiotics of art, this series shows a heightened level of physicality in her art; the circular forms inscribe her size and reflect in a direct sense the artist as a physical being. These paintings reassert the feasibility of expression, the personal projection of self in abstract painting, and allowed Steir

to continue mining the pictorial dialectics denoted in the opposition between the nature of image and image of nature. In *Last Wave Painting (Wave Becoming a Waterfall)*, 1987–88, Steir created an overtly transitional painting (fig. 14). It includes the prominent motif of her wave paintings: the large circles of paint indicative of waves. Each circle describes the artist's physical attributes in that her reach limits them, and it is strictly her reach that establishes the size of her circles. Steir's image is absent from her circles, but her physical self is thoroughly imposed on these paintings.

With the beginning of the waterfall paintings featured in this exhibition, Steir set out to capitalize on her recent discoveries. These paintings are indeed, as she calls them, "a little invention," and a late modern contribution to the history of art. They emerge from Abstract Expressionism and make plain the argument that that line of inquiry was left unfulfilled. Most artists since Pollock have been under his influence, but none of any stature have been able to do exactly what he did. His signature style was too hard to replicate, too much his own. There has never been a school of Pollock—a group of artists creating drip paintings on the floor as he did—and yet, most of the best painting since his death has engaged the new territory that he opened up for the medium.

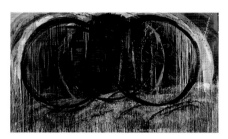

Figure 14
Pat Steir
Last Wave Painting (Wave Becoming a Waterfall), 1987–88
Oil on canvas
84 x 138 inches
Collection of the artist

For her waterfall paintings, Steir has gone back to Pollock's model and carried it further. As the poet and critic John Yau notes, Steir is not unaware that with her waterfall paintings she has entered a domain "considered synonymous with [Pollock]." This, Yau elaborates, begs an imperative question: "Is modernism's project dead?"[54] It further seemed to be a prophecy fulfilled by Steir's earlier postmodern work. As Yau explains,

> Given that Pollock is regarded as a solitary hero whose work inadvertently announces both the culmination and demise of modernism and the hand-painted painting, and this sense of demise is reinforced by the emergence of Andy Warhol and his use of mechanical means such as silkscreen, one senses that Steir is deliberately challenging this reading of recent art history, as well as recuperating aspects of Pollock's work and methodology.[55]

Steir realized that Pollock's work was not a terminus but rather an opening up of new territory. She has found room to go forward from Pollock—discovered a path to invention.

Her waterfall paintings, then, operate very much within modernism. This is not to suggest that Steir is completing Pollock's incomplete oeuvre. She has said, "…I wanted paintings that made themselves and so they needed gravity, they needed to have that. Also these paintings are in some way anti-Pollock. Because Pollock closed the field of painting. I am saying, hey, wait a minute. There is another approach to this."[56] She does not paint like Pollock, but rather takes the problems raised in his work to new levels. Pollock painted on the floor. He used thinned paint that retained a gelatinous consistency

54 John Yau, *Dazzling Water, Dazzling Light*, 62. This was a question that surfaced during the period of minimalism's ascendance. The key essay here was Douglas Crimp, "The End of Painting," *October* 16 (Spring 1981): 75; for debate on geometric abstraction's role as painting's endgame see, Yve-Alain Bois, "Painting: The Task of Mourning," and Elizabeth Sussman, "The Last Picture Show," in David Ross, et al., *Endgame: Reference and Simulation in Recent Painting and Sculpture* (Boston: The Institute of Contemporary Art, 1986), 29–50 and 51–70.

55 John Yau, *Dazzling Water, Dazzling Light*, 62.

56 Pat Steir, "Interview," 71.

so that as he dripped, the flow of paint could remain together as a steady stream. This allowed him to remain largely in control of his work. Early on, much was made of the wildness of his technique, but as those who knew Pollock attest, he had a great deal of control over the paint. It would flow or spatter largely where he wanted it, and gravity's only real role in the work was acting as an extension to his brush.

In *Sixteen Waterfalls of Dreams, Memories, and Sentiment,* 1990, we find a bridge between late Pollock and the new arena that Steir had created for herself (plate 3). In this painting there is a direct call for a spiritual interpretation based on the eighteenth-century notion of the sublime. This was an interest that began with her wave paintings and that Steir further refined and restated in her waterfall paintings.[57] The scale of *Sixteen Waterfalls of Dreams, Memories, and Sentiment* alone inspires awe. It suggests standing at the threshold of an unfathomable abyss where we witness some primordial act of creation. Steir recalls a seminal moment when she was standing on a beach at night and looking out into the infinite blackness of the unlit ocean. She attempts to evoke that feeling in her paintings—what are we who stand and contemplate this vastness. Her paintings reinforce the magnitude of human insignificance in the face of overwhelming natural power, an abstract sublime.[58]

Steir's paintings also betray her blending of the Western and Eastern versions of the sublime. She talks about her passion for scenes of a monk standing in contemplation of the waterfall in Chinese painting. He is contemplating the water and the enigma of the water

57 Steir says that, "The Wave was really more about fear and death, terror of death, than image, and I think in the artists I took it from it's about that too, in the Hokusai, in the Courbet." Pat Steir, *Gravures/Prints, 1976–1988* (Geneva: Cabinet des Estampes; London: The Tate Gallery, 1989), 11, cited in McEvilley, 57.

58 Robert Rosenblum, "Abstract Sublime," *ArtNews* 59 (February 1961): 38–41, 56, and 58. Robert Rosenblum first invoked the sublime as a further explication of Abstract Expressionism in 1961. His essay offered a reinterpretation of Edmund Burke's classic *Philosophical Enquiry into the Origin of Our Ideas of the Sublime and the Beautiful* (1757).

being both formless and having a form. In her paintings she also evokes, as Rosenblum contends of painters such as Clifford Still, the legacy of Frederic Edwin Church in making large-scale paintings that replicate that feeling of awe. Steir's paintings do just this. They are large enough for us to lose ourselves in them and to think of them as glimpses into an unknowable abyss—heaven, hell, a parallel universe—a place that is both overwhelmingly attractive and frighteningly vague. Her paintings are not only like waterfalls, they are water-falls; they result quite literally from a painterly version of a waterfall. So as viewers we have first-hand access to the experience. We are the monk in the Casper David Friedrich paint-ing or the Chinese painting. We can contemplate directly the fall of the liquid—the moments of its creation are frozen permanently in the painting. They are glimpses into the little big bang of their genesis.

At the outset, in the first group of waterfalls such as *Sixteen Waterfalls of Dreams, Memories, and Sentiment,* Steir severely limited her chromatic options, but in *Outer Lhamo Waterfall,* and the group of paintings completed after 1991, she greatly expanded the role of color (plate 4). Steir based the colors in the *Lhamo* series on those found in Tibetan *tanka* paintings.[59] Again, Steir uses art historical sources, only now more obliquely, borrowing a chromatic range peculiar to the *tankas* rather than their distinctive forms. Gender too plays a role in the color choices Steir makes. In her chromatic cosmography, monochromatic paintings are associated with a masculine principle, while the feminine is evoked in the brightly colored works. This is particularly evident in the *Lhamo* series where Steir refers directly to the three goddesses of Tibetan Bon lore.[60]

59 McEvilley, *Pat Steir,* 71.

60 Ibid., Bon is an indigenous religion predating Buddhism in Tibet.

Steir engages gravity to do the work in her waterfall paintings. Her role, her touch, is greatly diminished. This is her advance. The canvases are placed upright and made moist with water. Each waterfall is created from a single loaded brush—just one stroke. Her control is limited to contemplation of where and when to apply the stroke, and after that the interplay of the water on the canvas, the paint, and gravity takes over. Pollock spoke of being in the painting while creating it; Steir talks of moving herself out of her paintings. She spends most of her time in contemplation. The action is rather brief and it must be decisive. She moves to the canvas—often on a ladder—and makes the stroke. After that she watches as the forces she has put into action unfold beyond her control. Now it is the painting that seems to have the existential drive, the near-mythic power to will itself into being.

Steir's waterfall paintings also derive part of their essence from *Sumi-e* painting. They are not copies of this form of Japanese art, but Steir uses the technique as the basis for hers—the results are significantly different. In *Nocturne in Blue and Silver,* 1999, we see the cascading pigment as a background (plate 6). Steir uses the deep color and flowing form of the waterfall to contrast against the clarity of the spattered paint that appears on the surface. This updating of *Sumi-e* technique echoes Whistler's use of the same techniques (fig. 3). D. T. Suzuki described the *Sumi-e* technique for a wide American audience in his writings, many of which were scrupulously studied by the artists in this exhibition. Of particular importance to this discussion of *Sumi-e,* he wrote, "The inspiration is to be transferred on to the paper in the quickest possible time. The lines are to be drawn as swiftly as possible and the fewest in number, only the

absolutely necessary one being indicated. No deliberation is allowed, no erasing, no repetition, no retouching, no remodeling."[61] Steir has adopted this technique, especially its "flung ink" elements, to the creation of large-scale abstract paintings.

Steir takes some of her color cues from Chinese ceramic glazes. Many of her paintings from the late 1990s are characterized by metallic shimmerings within the paint that reflect light in a manner analogous to the reflective surface of glazes. Further, paintings such as the three-paneled *Foss,* 1996–97, result more from a sheeting action also reminiscent of the flow of glazes and pigments along the side of a ceramic vessel (plate 5). Wide expanses relate the prolonged journey of the thinned paint down the surface of the canvas. Only in the right panel do we find the thrown paint and gestural spatters of the earlier waterfalls. In *Foss* the creation seems more glacial than cataclysmic. Particularly the center panel evokes the invisible carving that water enacts on stone over thousands of years. Steir's connection with natural forces remains intact, but slowed. She has joined the temporal order of nature with the timeless ordering of the universe.

There are profound spiritual connotations in Steir's waterfall paintings. "A waterfall," Steir notes, "is always beginning and always ending and never beginning and never ending. So it's symbolically the sign for death and birth. When we think of the idea of rebirth we usually think of one person dying and the same person being reborn. Another way is to think of one person dies and another is born. And rebirth is rebirth of life, of nature, of earth."[62] In making her work, each time she completes a stroke, it is like the seventh day. She steps back to watch the thing she has set into motion (given life to) as it takes its own

61 D. T. Suzuki, *Essays in Zen Buddhism* (1934) (London: 1970), quoted in Westgeest, *Zen in the Fifties,* 16.

62 Pat Steir, "Interview," 72.

form. The difference is that mankind has been limited to creating objects. Despite much talk about artists as creators, metaphorically related to the creation story of most religions, the connection breaks down with scrutiny because the artists' creation does not usually display free will to shape its destiny. In Steir's process, the creation metaphor endures because her works have a kind of will of their own and her contribution is of such a limited physical nature—really, just a touch.

The strict adherence to a predefined methodology in Steir's art has roots in Conceptual art. Steir is conversant in the legacy of artists who have opted for paintings that paint themselves—at least conceptually. Her friend Sol Lewitt has made a career out of variations on this theme, and Steir finds great value in his example. "I feel that these paintings are very strongly Conceptual," she notes, continuing, "I chose a set of limitations to accomplish an end. The single brushstroke: it's the simplest thing you can do with paint."[63] Though the paintings depend for much of their impact on touch in the Abstract Expressionist sense of the term, she has disciplined indiscipline through her self-imposed parameters of action. She stands on the floor in front of her canvas. Her brush connects with the surface of the painting, emphasizing in true existentialist fashion her presence and actions at a specific time and place, but she also allows the paint a will—she emphasizes her ego and suppresses it simultaneously. That is the merger of existentialism and Dao that has allowed Steir to forge ahead into new areas of operation and essentially push forward the frontiers of modernism.

63 Quoted in Brooks Adams, "A Conversation with Pat Steir," in *Pat Steir: Elective Affinities* (New York: Robert Miller Gallery, 1992), unpaginated.

Brice Marden: "Spirit Resonance" and "Bone Structure"

The careful calculus of formal analysis falls short of evoking the full potential of Brice Marden's paintings—for that we must turn inward to the ineffable and elusive realm of the spirit. This is of course an arena in which words frequently falter—much of the best criticism on Marden relies indeed on allusion rather than explication. John Yau, himself a poet and critic, explains that "By evolving a purely private alphabet, he [Marden] expresses his desire to remain speechless, which is perhaps the only realm that cannot be appropriated by the narrative structures of either criticism or the media. At the core of Marden's subversiveness is his determination to leave the world of words behind, to remain in his own place of uncertainty."[64] Throughout his career Marden has endeavored to create an art of meaning. To this end, he makes paintings that consistently achieve a degree of metaphysicality while emphasizing, even asserting, their identity as handmade objects. For Marden, the formal relationships between suggestions of figure and ground, mark and grid, constitute a path that leads inwards to a more significant, if ill-defined, level of understanding.

Marden's career, like Steir's, has been a circuitous route away from, and finally back to, the magnetism of Abstract Expressionism. As Roberta Smith writes, "Franz Kline was one of his early heroes, but even as a graduate student at Yale, Marden started to react to what he saw as the clichéd gesturalism of the second generation Abstract Expressionists."[65] His early exhibitions in New York galleries, which began in 1966, established his problematic reputation as a leading minimalist. In paintings such as *Nebraska*, 1966, he created a largely undifferentiated monochromatic plane (fig. 15). His oft-quoted axiom, "As a painter I believe in the indisputability of the Plane," reinforced for many critics Marden's leading role in late

64 John Yau, "Brice Marden: The Desire to Undo the Self Until it Enters the Realm of the Modest and Private," *Flash Art* 142 (October 1988): 95.

65 Roberta Smith, "Brice Marden," in Nicholas Serota, ed. *Brice Marden: Paintings, Drawings, and Prints, 1975–80* (London: Whitechapel Art Gallery, 1981), 46.

modernism's enterprise.[66] He elaborated this point, explaining that his work is "…painting on a flat surface, a two-dimensional surface, basically rectangular. And that plane is created on that rectangular shape, and you work on that plane. So, it means you don't do things like collage, which is a layering."[67] Despite the essentially reductivist elements to his approach in these early paintings, the minimalist epithet would prove to be as misleading as the notion of monochrome. Marden bristles at the strict construction that sees art as entirely a matter of fact. He explains that "…to me a painting isn't just some facts…I mean if there's any working method, it's just keeping it open so you can put in as much as you want to put in…having an open situation rather than a closed situation—in opposition to Formalism."[68] His paintings then, as now, were attempts to overcome the factual.

The gray monochromes of his early paintings actually shift in color, leaning at times to green, at others to brown. The point was life; that his paintings could have life. "What I'd really like to make," he says, "when I make a painting is to make a life."[69] Colors that seem to shift suggest animation, something that has within it a power that allows for change, flux. Intellectually we know that the color is fixed, but our eyes tell us otherwise and this suggests an awkward conundrum. Are we to believe what we know to be true, or should we rely on the reports of our senses? If we follow the latter, we have entered into a different arena, one where our intellect is challenged by the evocation of something other. Marden has consistently encouraged this latter reading of his paintings, saying in the early 1970s, "The rectangle, the plane, the structure, the picture are but sounding boards for a spirit."[70] He sees his early work as existing in opposition to the formalist reduction witnessed in the paintings of

Figure 15
Brice Marden
Nebraska, 1966
Oil and wax on canvas
58 x 72 inches
Collection of the artist

66 Brice Marden, quoted in *Brice Marden: The Grove Group* (New York: Gagosian Gallery, 1991), 25. As Yve-Alain Bois points out, Marden had been making this point, and it had been discussed in the art press, for decades; the 1991 publication may, however, be the first time he was directly quoted. See Yve-Alain Bois, "Marden's Doubt," in *Brice Marden: Paintings 1985–1993* (Bern: Kunsthalle Bern and Weiner Secession, 1993), 57, n. 44.

67 Brice Marden (1980), quoted in Nicholas Serota, ed. *Brice Marden: Paintings, Drawings, and Prints, 1975–80.* (London: Whitechapel Art Gallery, 1981), 55.

other artists such as Frank Stella. "Art," according to Marden, "is made with the intention of creating something bigger than what you actually see."[71] This position is, of course, in direct contradiction to the minimalist construction of art with which Marden was so often associated.

Marden has downplayed the importance of Josef Albers to his paintings; after all, Albers left Yale in 1960, the year before Marden began his graduate work. But Marden's early paintings do bear a strong conceptual relationship to Albers's *Homage to the Square* series and he did study at the school the German master had steered for over a decade. Albers's color theories, about which Marden learned while still at Boston University, were never really theories in the formal sense, but rather carefully documented intuitions regarding the emotional potential for color and the responses he recorded regarding color combinations. Since his days at the Bauhaus (after completing his studies in 1923 he stayed on to teach until the school closed in 1933), Albers had sought to discover the expressive potential of pure colors.[72] To this end, he arrived at the simple juxtapositions of colors that characterize the *Homage to the Square* series, usually consisting of two to four square bands of undifferentiated color, all of which were designed to work in a singular harmony. In a sense, the layers of Marden's paintings, each one a coat of undifferentiated color, act parallel to Albers's bands—stacked rather than concentric planes of color each keyed into an unspecified, intuited emotional range.

Most importantly, however, would be the example of the square itself. What appeared to many critics—Albers was often as misunderstood as Marden—to be a sacrifice, was to Albers a great act of liberation. In the strict adherence to the square, the artist found infinite

68 Brice Marden quoted in Saul Ostrow, "Interview with Brice Marden," *BOMB* 22 (Winter 1988): 35.

69 Ibid., 37.

70 Brice Marden, "Notes, 1971–72," quoted in Serota, ed., 54.

71 Brice Marden, quoted in Paul Gardner, "Call It a Mid-Life Crisis," *ArtNews* (April 1994): 142.

72 See Nicholas Fox Weber, et al., *Josef Albers: A Retrospective* (New York: Solomon R. Guggenheim Museum, 1988), 287–92.

Figure 16
Brice Marden
Thira, 1980
Oil and wax on canvas
96 x 180 inches
The Musée National
d'Art Moderne, Centre
Georges Pompidou

potential. By ridding himself of unnecessary distractions, he focuses on universals that were, for the artist, quite spiritual in nature. Always religious, Albers transferred the pictorial traditions of Western religious art into a greatly concentrated form. Like Albers, Marden too found freedom in the aesthetic monasticism of severely limited forms and colors.

During the 1970s Marden introduced a new level of complexity to his paintings. He began to join his individual planes of color, still richly articulated in layers of wax and oil paint, together in a variety of combinations. Primarily diptychs and triptychs at first, the multiple panels characteristic of these paintings work to evoke the order that humans achieve most often in the service of religion. One of the grandest articulations of this formulation is *Thira*, 1980, an eighteen-panel polyptych (fig. 16). Its structure suggests the careful cadences of a

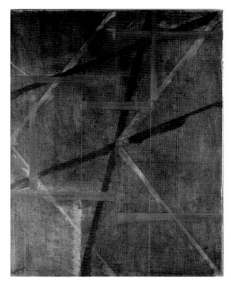

Figure 17
Brice Marden
*Window Study
Green & Red,* 1984–85
Oil on linen
26 x 20 inches
Collection of Nathaniel
and Jewelle Bickford

73 Marden himself provides the allusion to Piero
 in the context of *Thira,* noting that it "is an
 inside-outside painting, with an interior and an
 exterior space, like the Piero *Flagellation.*"
 Quoted in Jonathan Hay, "An Interview with
 Brice Marden," in Jonathan Hay, *Brice
 Marden: Chinese Work* (New York: Matthew
 Marks Gallery, 1997), 30.

Greek temple as well as the airless spatial organizations of Piero della Francesca's paintings.[73] In both cases, the allusions of Marden's paintings far exceed the facts of their material existence. They compact, restate, and advance the cause of the Western tradition in painting. Stephen Bann argues that the spiritual, even specifically religious, impulse thrives in Marden's art despite the widespread critical suppression such activity has had to endure throughout the twentieth century.[74] Bann evokes Ruskin's contention that color, when used "faithfully…is the holiest of all aspects of material things."[75] Marden, as it happened, was indeed then turning to a search for a means to make color immaterial.

In one of the great unfulfilled artistic commissions of recent memory, Marden was asked to design new stained glass windows for the cathedral in Basel, Switzerland. Though never completed, he worked on the project from 1977 through the mid 1980s. His attraction to the spiritual potential for color added greatly to his interest in the commission. Dozens of drawings and paintings, such as *Window Study Green & Red,* 1984–85, emerged from his work on the windows (fig. 17). In the judgment of many authors, this was the key activity that led to Marden's decision to move into the new work featured in this exhibition. The windows allowed him to ruminate on the Gothic appeal of stained glass, which made the immateriality of light plainly visible in a space dedicated to contemplation about, and belief in, an invisible force. In his 1981 essay, Bann had invoked Abbot Suger's inscription at Saint-Denis to conclude his essay on Marden's work: "The blind spirit

rises towards the truth by way of what is material, and, seeing the light, it is resuscitated

from its former submersion."[76] The pivotal aspect of the window commission for Marden

was the opening up, making overt his desire to get more light into his paintings.

Marden openly accedes to the exuberance evident in Bann's interpretation of his paint-

ings. He often finds the need to specify this aspect of his work in interviews. He confesses

that his "stuff is full of a kind of head in the clouds hedging..." and asks,

> What about magic?...How you could go and paint and work but there was only
> a small amount of time when you *really* painted. And that was when you were
> in another state. You're coasting right along, you're not even thinking. It's just
> all coming out. You're the medium, and to me that exists.[77]

These comments elicit the comparison to Jackson Pollock who likewise spoke of "being in"

a picture when he painted and who Marden consistently cites as influential (along with

Cézanne). The Pollock connection in Marden's earlier, essentially monochromatic paintings

had most to do with the quasi-mystical belief of the artist as medium, a relay station

between impulses of unknown forces and the canvas. When Marden began to paint the

works featured in this exhibition, all of which date to after 1985, his paintings began to

work more in accord with the arena of actions that Pollock carved out for himself. Marden

has internalized the lessons of Pollock, but has done so with a technique entirely foreign

to his Abstract Expressionist forebear.

The departure in Marden's work started in his drawings performed in the work books that he brought along on his travels around the world. As early as the *Untitled Work Book (Caribbean and Hydra),* 1982–83, he began to allow his line to meander, progressing across the paper and changing directions with curves and angles (fig. 18). His work on paper often involved markings of short duration and fixed direction—a change in direction usually necessitated the introduction of a new line. In the 1982–83 work book, many of the drawings include columns of seemingly related blocks (actually, purposeful smudges of ink, some scraped in a way that both lightened them to a medium gray and created tiny rivulets of ink that appear drip-like) and interconnecting lines. Marden drew bridges from one column to the next, often filling the "space" between his "figures." In an essay relating his detailed analysis of Marden's work books, Michael Semff says that in them "we find Marden engaged in a sustained effort to develop a spiritual system of drawing that places the direct observation of nature in a new context, defined by his study of Oriental calligraphy, which merges drawing, painting and writing into a united whole."[78]

At the same time, Marden was working on a series of drawings based on visual sources in nature. Following a trip to Thailand in 1983, he made groups of drawings based on seashells.[79] His attraction to the shells, "purely visual" he notes, centered on the small markings on their exteriors. Though he has referred to the shell drawings as portraits, they do not bear the appearance of shells; rather they portray the etched lines, some from growth, others from environmental occurrences, visible on the outside of the shells. Other drawings from the mid 1980s stem from following the direction of leaves and branches in

74 Stephen Bann, "Brice Marden: From the Material to the Immaterial," in Serota, ed., 7–14.

75 Ibid., 14.

76 Quoted in Ibid., 14.

77 Marden, quoted in Ostrow, 35.

78 Michael Semff, "To Reinvent Drawing for Oneself," in Dieter Schwarz and Michael Semff, eds., *Brice Marden: Work Books 1964–1995* (Munich: Staatliche Graphische Sammlung Münich; Winterthur: Kunstmuseum Winterthur; Cambridge: Harvard University Art Museums, 1997), 49.

79 Janie C. Lee, "Interview with Brice Marden," in *Brice Marden Drawings: The Whitney Museum of American Art Collection* (New York: Whitney Museum of American Art, 1998), 19.

the wind. Like the shell drawings, they do not depict the subject directly, but rather trace a vital, definitive gesture suggested by nature. The drawings in the *Untitled Work Book (Caribbean and Hydra),* 1982–83, as well as the shell studies and other drawings that he began the next year (some of which would appear in later work books), anticipated the transition he would soon undertake in his paintings.

Marden's mid-1980s turn to paintings largely inspired by the formal characteristics of Chinese calligraphy represents a transferal of idioms but not a fundamental alteration in the meaning of his art. Calligraphy offered Marden new ways of evoking meaning while continuing to avoid the specificity of language, visual or written. His choice of a formal language formulated from his study of a writing system set a particularly daunting challenge for an artist dedicated to non-objective painting. The transition documents Marden recoiling from a future of ever-greater refinements on a signature style that, while ceaselessly satisfying to those who followed his work, offered diminishing potential for the artist in terms of major discoveries.

In 1986, Marden completed *February,* the first painting in which he knowingly merged the painterly imperatives of his past art (along with those of Pollock and Cézanne) with an approach to drawing based on calligraphy (plate 7). The drawing aspect emerged from the group of ideas that had by then been much exercised in his work books; his new painting ideas required him to considerably rework his approach to date. He had long found immense satisfaction with his drawings and sought a way of transferring that immediacy and directness of touch to his paintings. Calligraphy offered him a path. The moment of

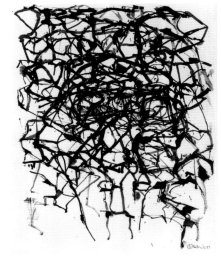

Figure 18
Brice Marden
Untitled Work Book (Caribbean and Hydra), 1982–83
Ink on paper
16 1/2 x 13 inches
Collection of the artist

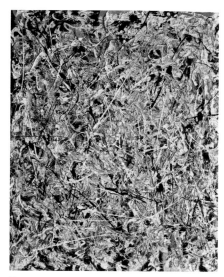

Figure 19
Jackson Pollock
White Light, 1954
Oil, enamel, and aluminum
paint on canvas
48 1/4 x 38 1/4 inches
The Museum of Modern Art,
New York

epiphany coincided with a 1984 visit to the exhibition, *Masters of Japanese Calligraphy, 8th–19th Century,* held at the Asia Society Galleries and Japan House Gallery in New York. Marden soon began a self-study of calligraphy that led him to Chinese examples of the form. In *February* he creates a web of veils and lines that obfuscate temporal clarity while allowing for a dim suggestion of spatial relations. The triangular forms, resulting from the many intersections of Marden's painted lines, carry a compositional weight greater than their individual station due to their repetition. These elements, often filled with washes of grey or white in *February,* would soon evolve into semi-detached figures or "glyphs" as Marden describes them.

Over the next few years Marden would further develop his technique and, again, it was based on ideas first explored in his drawings, many of which were performed with the end of an ailanthus stick dipped in ink. He chose his sticks carefully, his criteria founded on a balance between the control and lack thereof that the stick possessed. Using this intermediary between himself and the paper or canvas allowed himself to yield to nature a bit of control. This technique also gives his line an idiosyncratic flow—a bit hesitant, jittery, and oddly not like the lines one draws with shorter implements that bring the hand in much closer proximity to the paper.

Translated into a brush on an extended stick for his paintings, Marden's technique echoes, if faintly, Pollock's inimitable manner of applying paint to a surface (see fig.19). Generally the differences outweigh any similarities in technique between the two. Pollock poured his paint from a variety of devices, including brushes, down onto a canvas on the

floor, but Marden applies paint directly from a brush to a canvas mounted perpendicular to the floor. For this he has adopted the use of long-handled brushes—twenty-seven and thirty-three and a half inches long.[80] The stick or long brush offers him a manner at least analogous to Pollock's. As the paint left Pollock's brush (or stick or can) it flowed down toward the canvas in a trajectory determined by the gestures of Pollock's wrist, arm, and body, but in concert with the undeniable force of gravity. Due to the nature of paint, its gelatinous consistency, Pollock could control the direction of the flow briefly during the journey from brush to canvas. The degree of control was of course in reverse proportion to the distance of the paint from the end of the brush. Just as it left, though, he could still intervene obliquely as though painting with skeins of paint. Marden's long-handled brush, like Pollock's airborne paint, answers to the artist's will but not without some resistance, not without asserting some manner inherent to its nature into the creation of the lines.

Over the next few years, 1987–88, Marden worked on a group of paintings in which he explored new roles for the glyphs in his paintings and at the same time greatly refined his techniques. The glyphs, which were now less frequently covered with the thin veils of paint found in *February,* often merged into an interpenetrating series that extended across the canvas in nearly unbroken webs as they do in *4 (Bone),* 1987–88 (plate 8). The dominant ochre tones of the ground pulsate gently between areas of higher and lower intensity. The result of repeated scrapings, it bears the marks of its creation openly. Marden does not elaborate on any specific temporal order in the ground, but the multiple markings on the

80 Brenda Richardson, "The Way to Cold Mountain," in *Brice Marden: Cold Mountain* (New York: Dia Center for the Arts, 1992), 67.

surface bear witness to the countless events that constituted its creation and suggest that it has endured changes over an extended period of time. He organized the lines into two zones of activity, left and right, with several bridges joining the sides. These two vertical figures evoke bodily references, especially when considered in the context of the title.

Marden has continually used titles for their allusive potential, preferring to suggest meaning than to abandon the work to the strict formulations of formal analysis. Since the beginning of his career, as Klaus Kertess writes, Marden has "rejected the purely phenomenological, analytical notion of art that had motivated so much work in the Sixties. For him, painting fully emancipated from myth, spirit, and metaphor is painting afflicted with paralysis of meaning."[81] Indeed, the reference to bones should be considered allusively. As a way of describing the continuity in his work, Marden observed of his linear, post-1985 paintings, "They're like the skeletons of my early paintings. The connection is there."[82]

Marden's painting technique at the time he completed *4 (Bone)* bears only the most basic resemblance to that of the earlier drawings that had inspired him. He talked of wanting the same immediate qualities achievable in drawings for his paintings, but lamented that the process of applying paint was too utterly different to make the transition directly.[83] At the same time that he expressed his desire for the spontaneous simplicity of pen and paper, his painting technique, never quick, grew even more labored.[84] It became a process of adding and subtracting, painting and scraping, revealing and obscuring. Marden paints with brush and knife in hand.[85] For almost every direct brush stroke there is an adjustment. Typically, he scrapes the excess paint off the length of a stroke, leaving a thin

81 Klaus Kertess, *Brice Marden: Paintings and Drawings* (New York: Abrams, 1992), 29.

82 Gardner, "Call It a Mid-Life Crisis," 142.

83 Marden comments that "One of the things I like about a drawing is that it's a very direct form of expression, whereas a painting becomes an evolved statement because of the materials you're using. It's paint and it's color. You can correct it more; you can refine; you can take it to a different kind of refinement. Whereas a drawing can be very refined just because it's so direct and there's so little between you and the expression." Quoted in Janie C. Lee, *Brice Marden Drawings,* 23.

84 His monochrome panels were built up from multiple layers of individual colors applied in a wax and oil paint medium. The layers, visible from the side of the unframed panels, charted the different feelings that Marden added to the mix as he worked on the panels. These panels were, in other words, the result of prolonged periods of activity.

85 This description of Marden's technique is a reduced and rephrased version of that so eloquently offered in Brenda Richardson, "The Way to Cold Mountain," 66–69.

mark, almost a stain, as a record of the original action. He also uses terpineol to reduce the strength of some lines or areas. This accentuates the translucent layering in his paintings; it can also lead to shifts in the pigments as the colors mix on the canvas. He describes the process of changing the lines as one of "erasures" or "cancellations," but as Brenda Richardson observes, "The erasures are positive, active, and composed—that is, painted, drawn. When applied marks are 'erased' with solvent, the artist controls the degree to which the black lines mutate and dissolve into the painting's ground color."[86] In the same way that the negative space in Asian art is considered a positive presence in the composition, Marden uses subtraction as addition in his paintings—the act of obliteration and obfuscation in his painting process is as much a part of the action of constructing the final image as is applying the paint.[87]

Marden's attraction to calligraphy is largely formal; he is not particularly interested in the meaning of the individual characters. But, to understand the formal attributes of calligraphy from a strictly Western point of view would lead to misunderstandings of Marden's attraction to the form. In Chinese aesthetics, Marden's chief source, the spirit, that unseen and elusive aspect of art, has been considered the first principle of art—that includes calligraphy—since before the sixth century. At the time the critic Hsieh Ho wrote his *Lu Fa,* in the late fifth century, he introduced his six principles or canons of painting by admitting they were not his, but an articulation of inherited wisdom. These precepts for the formulation of an image have endured through the centuries and remain the theoretical gateway into comprehension of Chinese painting.

86 Richardson, "The Way to Cold Mountain," 69.

87 The importance of the erasures in his work are clearly a departure from Chinese calligraphy, where the ability to make each line with only one pass is one of the most basic criteria for quality. These erasures also evoke a connection to the European manuscript tradition—if the scribe made a mistake, he would scrape the pigment off the vellum, inevitably leaving traces of the rough surface under the replaced letters. The temporal ordering made evident from erasures in Marden's paintings merges Western writing traditions with the Eastern calligraphic sources so far considered.

As Mai-Mai Sze writes, the first two of Hsieh Ho's six canons are the most impera-tive. "The First and Second Canon established the basic metaphysical principle and the means of expressing it."[88] Directly translated, the first two canons are "spirit revolving life stirs," and "bone means use brush."[89] Oswald Sirén offers a meaningful transliteration of these two primary ideas as: "The first is: Spirit Resonance (or, Vibration of Vitality) and Life Movement. The second is: Bone Manner (i.e., Structural) Use of the brush."[90] These two ideas, that paintings must have spirit and structure, form the conditions for success in Chinese art. For at least fifteen centuries, those paintings that have been treasured, protected, studied, and exhibited have satisfied the criteria set out by Hsieh Ho. Further, scholars of Chinese art emphasize that the order of Hsieh Ho's principles reflects the rela-tive significance of each idea, especially regarding the primacy of his first proscription. "The First Canon," writes Sze, "remained the basic and indispensable principle, controlling the other five and applying to all kinds of painting."[91] The point is clear: great art evokes some-thing greater than itself; it alludes to the existence of the spiritual.

Michael Sullivan's study of Chinese painting, poetry, and calligraphy, *The Three Perfections*, provides the crucial link in understanding the relationship between Chinese painting and Brice Marden's art since the mid 1980s. Sullivan argues that the metaphysical backbone for calligraphy and painting are one and the same. Text and image cohabit the same plane in most traditional Chinese painting. Sullivan points out that, "In Chinese paint-

88 Mai-Mai Sze, *The Way of Chinese Painting* (New York: Vantage Books, 1959), 53.

89 Ibid., 52–53.

90 Oswald Sirén, *The Chinese on the Art of Painting* (New York: Schocken Books, 1963), 19.

91 Sze, *Way of Chinese Painting*, 54. Sze's reference to "all kinds of painting" includes calligraphy, as the brushed form of writing was considered an integral part of painting.

ing space is simply—space, the matrix out of which forms emerge, the medium in which they are related," and, he continues, "the poem is as much a part of the total work of art as any object that the painter puts in, and has as much claim to the picture space."[92] Sullivan marches out samples of Chinese art criticism written centuries apart that support his basic contention. One thirteenth-century writer, for example, insisted that the two artists about whom he wrote, "being good calligraphers they were inevitably able painters, being good painters they were inevitably able calligraphers: calligraphy and painting are essentially the same thing."[93] In conclusion, Sullivan opines that the tenets for painting established by Hsieh Ho were derived from a body of thought pertaining to calligraphy first and then painting. Ultimately, then, the painting and calligraphy in traditional Chinese art were judged by the same criteria. The structure of the work was important, but secondary; the utmost concern was for the spiritual vitality that the work embodied.

As Marden's work proceeded, his involvement with direct calligraphic sources ebbed and flowed. For the *Couplet* series, the connection was fairly strong. Based on the couplet form in Chinese poetry, Marden created paintings that evoke the patterns of a poem on a page. In *Couplet IV*, 1988–89, Marden's rows of glyphs morph into tangles of interpene-trating journeys (fig. 20). As in Kline's work, the interstices play a dominant role in the over-all composition—they are for Marden more than rests or visible areas of ground. They play a role as shapes that dance around the surface demanding attention. The lines themselves

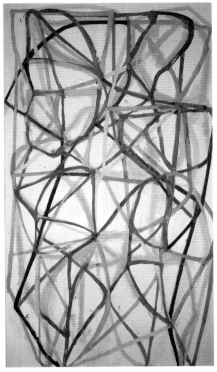

Figure 20
Brice Marden
Couplet IV, 1988–89
Oil on linen
108 x 60 inches
Collection of the artist

work in an odd reversal, described by Yve-Alain Bois as contradicting the "temporal and spatial orders."[94] The lines that appear spatially closest appear to have been painted earlier rather than later due to the order Marden creates with the lines that pass over (later) and those that pass under (earlier). By also varying the hue intensity of these lines, he has been able to confound simple pictorial logic and that "provokes a spiraling effect, a to and fro, that is visually uncontrollable."[95] This dizzying effect of tracing Marden's lines should not be misconstrued as evolving out of a desire for creating confusing visual or optical effects. They are journeys, each rich and largely unpredictable, much as is life.

Couplet IV overtly suggests a corporeal metaphor as well, a suggestion subtly encouraged by the artist. Marden has said that "I always figure that my vertical paintings are figure paintings, and the horizontal ones are landscapes, and the square ones are abstract."[96] While we should not take Marden's axiom too literally, we find ample visual support for it in *Couplet IV.* The top-heavy configuration of Marden's lines approximates the visual density of bodies—they gain visual weight as we move up through the paintings. The tops are semicircular, loosely reflecting the lines that would delineate head and shoulders in a drawing. Further, the lower extremities are denoted by lines that tend (with the sole exception of the yellow one on the right) to terminate at the bottom and reverse direction. Finally, Marden's title evokes a play on couplet and couple, giving the animated movements of the lines through space the allusion to dance—an idea that he explored directly in later paintings such as *Tang Dancer,* 1995–96.

92 Michael Sullivan, *The Three Perfections: Chinese Painting, Poetry, and Calligraphy* (New York: George Braziller, 1980), 7.

93 Ibid., 17.

94 Bois, "Marden's Doubt," 35.

95 Ibid.

96 Hay, "An Interview with Brice Marden," 30.

There have been many critics who have relished a variety of corporeal metaphors in relation to Marden's work. In addition to the skeletal reference, Bois points to the plethora of skin analogies found in the criticism of the earlier, essentially monochromatic paintings.[97] Bois uses this critical abundance to defend the fact that he, for one, cannot accept the calligraphic model for Marden's paintings despite the artist's personal advancement of the source. For Bois, the body is a more appropriate frame of reference, though he nominates the lungs as the closest analogue as they evoke breath and pulmonary associations. He summarizes the appeal of his reading by reiterating that "the lung image requires a good many conditions to emerge. It is not enough for a painting to look like one, it must also pulsate; it is not enough to pulsate, it must also draw you into its tangles; it is yet not enough if it does that, for it must also permit the circulation of air between its discrete but similar elements: it must be woven in space."[98] Bois's respiratory image adds an original and convincing layer to the already complex interpretative literature on Marden's paintings.

Bois, by dismissing the relevance of the calligraphic sources in Marden's work, may have instigated an inspired response in the form of Jonathan Hay's 1997 catalogue for the *Epitaph* paintings. Titled *Brice Marden: Chinese Work,* the book contains detailed pictures charting the evolution of Marden's paintings from a strict calligraphic source—literally copied from an eighth-century limestone inscription—through the many stages of transmutation as the original characters become the endless meandering lines of Marden's finished

97 Bois, "Marden's Doubt," 53.
98 Ibid., 51.

Figure 21
Brice Marden
Study for Epitaph Painting 2,
1996
Ink and collage on two
sheets of paper
40 ¼ x 60 inches overall
Collection of the artist

99 Jonathan Hay, "Marden's Choice," in Hay,
Brice Marden: Chinese Work, 10.

paintings (see fig. 21 and plate 11). This alone would only prove where he began, however,

and that was not the issue for Bois. The point of contention comes from Bois's construc-

tion of the properties inherent in calligraphy that do not appear in Marden's finished works.

But Hay counters, "the characteristics which Bois attributes to calligraphy have in each

case been accompanied historically by an internal critique. I would even go so far as to say

that the very practice of calligraphy is founded on the tensions between the grid and its

decomposition, between unilinear temporality and a pictorial negation of that temporal

order, and between graphic flatness and surface depth."[99] To disavow the influence of

calligraphy in Marden's work is not to deny the obvious, but rather to avoid the inscrutable.

Formal analysis provides insight into the bone structure of Marden's paintings, but we must attempt also to address their "Spirit Resonance" if we are to fathom their full potential. This, as the critics Hay, Yang, Gelburd, and De Paoli, among others, have pointed out, presents a monumental challenge to modernist criticism.

In *The Attended,* 1996–99, Marden stresses clarity and avoids the very reversals of temporal order that Bois described as creating a "spiraling" (plate 10). Now the lines adhere to a strict ordering that not only elicits comparisons to earlier twentieth-century abstraction in terms of its suggestions of space, but offers viewers an accessible code for comprehending the conduct of the lines.[100] Rather than the "braiding" of lines, these stack up—red over yellow over green over white.[101] Furthermore, Marden weights the whole to the left. The yellow line seems to lean left and at its likely terminus in the bottom left corner, it becomes a brief plane, a rare return of the veiled interstice more common to his earlier works such as *February*.

The Attended evidences the appropriateness of Bois's respiratory analogy—it breathes—*and* supports Hay's description of calligraphy, particularly in the simultaneous adherence to and decomposition of the grid. The painting offers a clearer articulation of Marden's connection to Chinese art and presages his continuing refinement of this practice. Marden likes to think in terms of aesthetic advancement and his *Attendant* series attest to this.[102] In discussing how each painting he completes leaves open questions and his next will serve to move forward, Marden says, "I still consider myself a modernist in the sense that I am always trying to continue or improve what was there before."[103]

100 In the exhibition catalogue that accompanied the debut of these paintings, Harry Cooper discussed Marden's imposition of an absolute rule in contradistinction to Mondrian's work in New York. See, Harry Cooper, "Marden Attendant," in *Brice Marden* (London: Serpentine Gallery, 2000), 17.

101 Cooper coined the descriptive "braiding." Ibid.

102 The series now includes six paintings, the first five of which are titled, *Attendant 1–5; The Attended* is the sixth in the series.

103 Jonathan Hay, "An Interview with Brice Marden," 20.

Figure 22
Michael Mazur
Closed Ward #9
(The Occupant), 1962
Etching and aquatint
23 3/4 x 17 3/4 inches
Jane Voorhees
Zimmerli Art Museum

104 Portions of this section appeared in modified
form in John Stomberg, "A Delicate Balance:
The Art of Michael Mazur," *Art New England*
21 (June/July 2000): 26–27, 75.

Michael Mazur: A Delicate Balance

Michael Mazur's path to his recent paintings based on Chinese art has been less than linear.[104] When he left school in 1961, Greenbergian formalism had what Mazur perceived to be a stranglehold on American art. He felt deeply that the work laid out by Courbet could be continued, reinvigorated, molded to his own needs in the context of twentieth-century society. Over the decades, Mazur has channeled much of his energies into printmaking, especially monotypes. And throughout his career, much of his art has reflected the search for a delicate balance between the process of making visual images and his literary concerns. He has been unwilling to accept the kind of purism espoused by the generation preceding him that insisted on the separation of painting or printmaking from written art. Hybridity has been a characteristic of Mazur's work since his earliest exhibitions. This is particularly evident in his signature monotypes, the medium that marries painting and printmaking. His directly literary work, such as the images for Dante's *Inferno,* overtly combine literature and imagery. And most recently, in his work that combines Western art and Chinese landscape traditions, he creates liaisons between different cultural impulses. Mazur has found in Asian aesthetics a key to uniting the illusive with the allusive in a potent new visual form.

His earliest exhibitions (which started in New York in 1961) featured series of etchings with aquatint. The group titled *The Closed Ward* reflects the humanist expressionism that dominated his art in the 1960s (figs. 22 and 23). Mazur plumbs deeply into the disparity

between the physical passivity of these residents and their psychic battles. This early print suite uses an arrangement of lights and darks that visually echo the central conflict of the narrative. These prints blend compassion with horror and carry on a tradition that links Callot and Goya to Kollwitz and Rouault. This lineage was first made manifest for Mazur in the work of Leonard Baskin, in whose studio at Smith College he worked occasionally while a student at neighboring Amherst College, and then in the example of his teachers at Yale, especially Gabor Peterdi and Rico Lebrun.[105] Mazur's assertion of emotionality in a narrative format established his willingness to repudiate the tenets of New York School formalism in favor of a literary art of meaning.[106]

During his time printing at Baskin's studio, he befriended George Lockwood, who would later open Impressions Workshop in Boston. In 1965 he began work on a rephrasing of the themes and images from the *Closed Ward* series in a suite of lithographs editioned at Impressions Workshop. That set, *Images from a Locked Ward,* allowed Mazur to refine his efforts at finding visual corollaries for states of psychological extremity. In *Images from a Locked Ward #10 (Bound Hands Swing),* for example, Mazur again uses the stark contrast between the bright white and the deeply saturated black to suggest this woman's life in the shadows. It is the artist himself who, by virtue of his looking, casts light on the dark world she inhabits. She is crowded into the image's borders, her inability to stand up reinforcing her incarcerated status. Her bound hands—done as often to defend against the

Figure 23
Michael Mazur
*Closed Ward #14
(The Three Beds),* 1963
Etching and aquatint
27 1/2 x 38 1/8 inches
Jane Voorhees Zimmerli
Art Museum

105 Trudy V. Hansen, "Michael Mazur: Entering the Stream: An Introduction," in Trudy V. Hansen, et al., *The Prints of Michael Mazur* (New York: Hudson Hills Press, 2000), 18–19.

106 In terms of his early reputation, see John Canaday, "Art: For Sake of Expression, Not Esthetic Theory," *New York Times,* 5 March 1966, 23.

Figure 24
Michael Mazur
Wellesley Greenhouse, 1976–77
Oil on canvas
72 x 84 inches
Corporate collection, Paris

patient's own self-immolation as to protect those around her—detail the specifics of Mazur's observation and connect with the grand thematic legacy of suppressed freedom and repressed humanity in art and literature, themes that pervade Mazur's early work.

By the mid 1970s, Mazur's paintings began to carry forward the broad themes of circumscribed vitality that had occupied his prints a decade earlier. Now the references were more oblique, metaphysical, and less overtly emotive in nature. Typical of this period, in *Wellesley Greenhouse,* 1976–77, he painted great tropical flora, fantastic and lush, whose natural forms are delimited by the geometric regularity of the greenhouse that contains them (fig. 24). He also completed a series on monkeys who loom large and proud in the meager surroundings of their cage at the zoo—*Cage at Stoneham #4,* 1977 (fig. 25). Even when he turned to the landscape, it was not to be the boundless expanse of mountains or sea, but rather to the controlled, tamed, and constrained nature found in suburbia, such as *Garden View, No. 2,* 1978.

These paintings evoke in their subject matter issues related to their formal means as Mazur pushed the tension between painterly and literary issues. If the tropical plants and the animals are understood as the artist's thoughts and emotions—that which goes into his art—then the greenhouse/cage becomes the work of art that confines for the sake of communication. Art in its greatest, purest state replicates nature unbound, but is unknowable and incommunicable. In the process of capturing thoughts and emotions, an artist necessarily binds them into form. Too free, and the work is indecipherable; too tight, and the

vitality of the expression is lost. At the very moment of recognition, at the instant we know something, the inexorable movement toward captivity begins. Likewise, the artist's vision is truest in its unuttered state and creation is a process of caging. Mazur's caged flora and fauna mournfully evoke the limits of art while celebrating its vast potential by addressing the tension between knowledge and freedom.

Much of Mazur's work over the years has also had about it an elegiac quality that derives from his interest in addressing the passage of time. Time is a familiar tool in litera-ture and poetry, film and theater, dance and music, but not terribly obliging for a visual artist. On the surface, we comprehend images all at once. How then do paintings and prints access the potent evocative power of time? In the broadest sense, all of Mazur's work—and arguably all artwork—deals with temporal issues, but he has consistently returned to this theme in a direct manner. In the early 1970s, in his conceptually based works such as *New York Memory Sequence #1* (1972), for example, he used the ghost images left during the creation of monotypes to make prints that literally document time passing. After printing the first image, he added new elements without re-inking the original scene. The resulting second print has the new features clearly printed, while the first image has receded like a memory or an echo. Successive additions and printings created suites of prints that chronicle the duration of their making while fabricating a narrative of time.

Figure 25
Michael Mazur
Cage at Stoneham #4, 1977
Oil on canvas
48 x 80 inches
Private collection

Figure 26
Michael Mazur
Wakeby Day II, 1983
Monotype (triptych)
Left panel:
71 1/2 x 43 1/2 inches
Center panel:
71 1/2 x 47 3/8 inches
Right panel:
71 1/4 x 43 1/2 inches
Brooklyn Museum
of Art, New York

In his monumental 1983 monotype triptychs, *Wakeby Day* and *Wakeby Night,* Mazur's technique allowed him to construct images of subtle complexity and eloquence (see for example fig. 26). These prints continue the artist's focus on time in that each presents the scene with its temporal opposite as an insert—night set into day and day set into night. To achieve the unprecedented scale of these monotypes (both of these triptychs are about six feet high and eleven feet wide), he used a variety of rollers and plates to lay the richly layered images onto the plate from which the prints were created. Regardless of the specific medium of transfer, Mazur allows each passage to remain somewhat distinct in a manner that both emphasizes the work's construction and complicates its visual poesy. If we could

write in phrases, that is, if instead of individual words we had characters that represented whole thoughts—more like the characters in the Chinese language—then we would have a corollary for the monotype technique Mazur used in his *Wakeby* prints. By using whole images, he creates the complexity of whole thoughts rather than single words. The finished works evoke motion, the passage of time, growth, decay, and myriad other notions without being backed into the corner of specificity. These prints clearly chronicle the intensity of the performance that accompanied their creation.

In the 1990s Mazur both culminated his work in monotype and set off in a completely new direction with his paintings. In 1992, he began work on illustrations to accompany the new translation of Dante's *Inferno* that poet Robert Pinsky was then preparing.[107] This project became more of an obsession than a commission for the artist. Mazur had first read Dante in Italian in the 1950s and had contemplated the poem on and off ever since.[108] (Indeed, his early reading of the *Inferno* might have offered Mazur a point of emotional reference for his *Closed Ward* series.) He worked closely with Pinsky; they exchanged drafts and sketches for over a year. Mazur blended the personal with the universal in his images—matching his approach to Dante's. For the frontispiece, he chose an image of Charon's boat, from *Canto III,* as it heads off to the distant shore, the side of "fire and ice." It is no accident that Mazur used his fingerprints to create the marks that designate the souls. Mazur internalized Dante's themes deeply and created images of immediate and undeniable potency that far surpass our notion of illustration. As Pinsky has suggested, Mazur's images will become part of how we understand Dante.[109]

107 Robert Pinsky, *The Inferno of Dante: A New Verse Translation*, bilingual edition, ill. by Michael Mazur (New York: Farrar, Straus and Giroux, 1994).

108 Michael Mazur, "Illustrating Dante's *Inferno*," in Stephen Prokopoff, Michael Mazur, and Robert Pinsky, *Monotypes by Michael Mazur for the Inferno* (Iowa City: University of Iowa Museum of Art, 1994), 5–6.

109 Robert Pinsky, "Notes on a Collaboration," in Prokopoff, Mazur, and Pinsky, *Monotypes by Michael Mazur*, 12.

Figure 27
Michael Mazur
*From the Garden of the
Sleeping Lions,* 1989–90
Monotype on silk
60 x 60 inches in 6 sections
Collection of the artist

A few years before he began work on the Dante monotypes, Mazur had started to for-
mulate ways to articulate his interest in Chinese landscape. His 1987 trip to China had led
to a growing suspicion that Chinese visual culture (from paintings to gardens) held a great
revitalizing potential for his own art. Mazur began to experiment with printing and painting
directly on silk. Since his return from China, he had been increasingly importing sugges-
tions of Asian aesthetics into his work. One of the first works he completed in response
to his Chinese travel was a six-panel monotype on silk, *From the Garden of the Sleeping
Lions,* 1989–90, that combined landscape elements with architectural motifs from the gar-
dens he had visited (fig. 27). This marked the beginning of his search for a way to infuse
his art with something of the spiritual depth that he found in the Chinese art he so
admired. These first works incorporated architectural elements as well as suggestions of
garden designs—Mazur, like Marden, had spent time in the famed gardens at Suzhou. The
creators of these gardens labored to make their efforts appear the result of natural forces
rather than those of humans. Though pure artifice in the sense that every element in these
gardens represents someone's choice of placement or selection, the patterns of growth
give the feeling that the plants and mosses have existed for all eternity.

Early on Mazur realized that he would not need to embellish on these gardens.
Replicated in his realist style they could indeed provide the profundity he sought. But his
very approach to realism was changing in response to his journey and what he saw.
Among the first works he did in direct response to his trip was a group, here represented

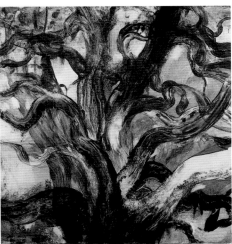
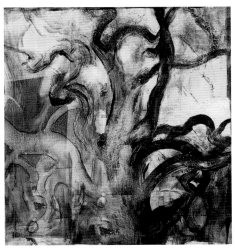

Figures 28, 29, 30
Michael Mazur
Oak II, Oak III, Oak V, 1989
Monotype on silk
32 x 32 inches each
Collection of the artist

by *Oak II, Oak III,* and *Oak V,* which focus on singular trees as exemplars of all the forces

that these gardens had imparted to the artist (figs. 28, 29, 30). These works, painted on

silk, betray a considerable loosening up in his application of pigment. Inspired now by a

variety of Chinese painting and calligraphy, Mazur allows his brush the freedom to linger

or accelerate in response to his own intuited gestures—themselves responses to the sub-

jects. His brushwork no longer answered to the dictates of replication, but rather to the

momentary imperatives of his mark-making. As well, he allowed the media—the paint and

the silk—to have a hand in the process. The pigments stain and extend beyond the direct

path of his brush as the liquid is aborbed by the dry silk. Mazur can only control this so far

and these works on silk denote a turning point in his personal philosophy on creation. Like

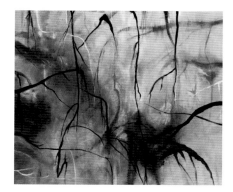

Figure 31
Michael Mazur
Avalanche, 1993
Oil on canvas
Private collection,
Portland, ME

110 Michael Mazur, quoted in "Mazur's
 Monotypes: The Medium with a Memory,"
 in Hansen, *Prints of Michael Mazur,* 92.

111 Michael Mazur, "Chao Meng-fu: *The Mind
 Landscape of Hsieh Yu-yu,*" *ArtNews* 95
 (November 1996): 848–85.

the master gardeners of Suzhou, Mazur now worked to create in concert with his media, instigating the growth of his work, but not dominating every minute passage. With these works Mazur was combining his will with that of the silk and the paint.

In the early 1990s Mazur worked on a series of paintings that explored the body metaphor directly. These works built on the compositional and analogical precedents of his *Oak* series. Partially the result of a traumatic operation that the artist endured—angioplasty to correct angina—these works combine Mazur's new, more gestural approach to mark-making with references to the pulmonary system. "In the process of going through that," Mazur says of his operation, "I saw images of the heart or of the body that were like landscape images."[110] These works metaphorically combine the capillary action of blood vessels with branches, suggesting the organic unity of nature and our part in that unity. He worked with the visual similarities between veins and branches to invoke the allusive potency of both. In 1993, for example, he painted both *Arterial* and *Avalanche,* works characterized by extended brushstrokes that meander across the surface of the painting (fig. 31). These long marks, each recording the movement of the artist's hand and arm, increasingly interested the artist as singular elements. Mazur began thinking of them in the context of the Chinese art he had seen.

That same year, 1993, he began researching the history of one particularly compelling painting, *The Mind Landscape of Hsieh Yu-yu* (by Chao Meng-fu, 1254–1322), as a possible method of bringing Chinese culture into his life (fig. 32).[111] This Yuan dynasty landscape

painting had a particularly strong resonance with Mazur's extant work and suggested new

directions for the artist as well. Chao Meng-fu was himself an artist recognized for his

staunch maintenance of traditional art; he said "The most important quality in painting is

the spirit of antiquity. If this is not present, the work is not worth much, even though it is

skillfully painted....My pictures seem to be quite simple and carelessly done, but connois-

seurs will know they are very close to the old models...."[112] Mazur also built on his prede-

cessors, only now he was adopting a new set of references. He says of this period when

he was studying Chao Meng-fu intensely, "there was a connection with my own work that

led to a group of pieces based on deconstructing and reconstructing his images and mak-

ing them my own, just as he might have done with the work of a predecessor in China."[113]

Mazur's work on this painting would lead him into distinctly new visual terrain.

In particular, Mazur focused on one detail of Chao Meng-fu's painting that he found

reproduced in a book. Rather than individual brush strokes working in unison to describe a

tree, as is traditional in Western painting and was to a large extent how Mazur had painted,

he now evoked the tree with a singular wash of paint. In his series of paintings titled *Mind*

Landscape after Chao Meng-fu, Mazur represents the landscape without depicting it

(plates 12 and 13). His subject is less standing in nature, or even trying to replicate that

experience, but rather thinking about landscape art. His series deals with an aesthetically

inspired state of reverie. By evoking each element with broad patches or long strokes of

paint, he also borrows something from his study of calligraphy.

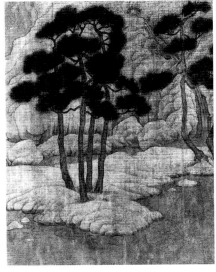

Figure 32
Chao Meng-fu
*The Mind Landscape of Hsieh
Yu-yu (Yu-yu ch'iu-ho)—detail*
Late 13th century
Handscroll; ink and
colors on silk
27.4 x 117 cm (painting);
27.4 x 214.3 cm (colophons)
The Art Museum,
Princeton University

112 Chao Meng-fu, quoted in Sirén,
 The Chinese on the Art of Painting, 110.

113 Michael Mazur, quoted in Hansen,
 The Prints of Michael Mazur, 92.

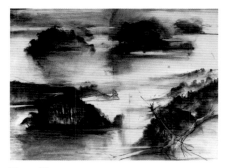

Figure 33
Michael Mazur
Wakeby Islands, 1963
Charcoal on paper
19 x 25 inches
Private collection, Boston, MA

Unlike Marden, Mazur is not borrowing from the formal elements of the Chinese written form, but rather from the structure of its language. In the poetry and colophons added to Chinese paintings, as well as in independent examples of calligraphy, the meaning of each character shifts in subtle ways depending on context. The inherent structure of the Chinese language lends itself to allusion—each character carries a range of potential references. Mazur applies this aspect of the tradition to his painting. Still essentially a form of realism, Mazur's paintings since 1994 embrace ambiguity. Are the forms in these new paintings and prints trees in a landscape or floating forms in the sea? They are, of course, both—they are the essence of the natural world evoked obliquely through visual means. A mark is a tree, a branch, a cloud, a stream, and none of these. Mazur's use of a painted mark as a tree works as a visual metaphor for the individual characters that evoke the idea of tree, thereby linking his new work to a literary tradition, especially to Chinese poetry, much as literary concerns had informed his earlier work.

Despite the radical shift in appearances for Mazur's post-1994 work, there are legacies of his earlier works in the new series. The idea of composing with whole visual elements, that is, laying on images that are to a large degree complete in themselves, derives in part from his work in monotype. In the *Wakeby* series, for example, the complexity of meaning comes from the juxtaposition of mature, multifaceted visual ideas (fig. 26). When he made his personal discovery of the Chao Meng-fu painting, Mazur was

also responding to the recognition of kindred forms between his own earliest work and Chinese painting.[114] In a 1963 charcoal drawing titled *Wakeby Islands,* for example, Mazur depicted islands in a small pond repeated in the four quadrants of the composition (fig. 33). The image merges realism with abstract patterning and breaks down the specificity of the referent in a manner consistent with his later work. Though he entered largely new visual terrain with his paintings and prints based on the study of Chinese aesthetics, Mazur was still covering ground with which he was quite familiar. He merged his own experiments with the limits of a pictorial tradition that traces its ancestry to Renaissance Italy together with his understanding of Chinese painting.

In the painting *Dragon's Rockery,* 1997–98, as well as the related print, *Dragon's Rockery I,* 1997–98, Mazur directly engages the ideas of the garden in his art (plate 14 and fig. 34). Where the chromatic range of his earlier works leaned toward the earth tones of Chinese ceramics, for the *Dragon's Rockery* group Mazur relies heavily on the grays and blacks of a winter garden. In the painting, he has added a small streak of red that activates the surface and suggests a vital force seemingly lost in the darker tones. In terms of his formal relation to observable reality, this group marks a particular extreme for the artist. These images hover on the brink of non-objectivity. The forms and marks operate with unprecedented independence—in the context of Mazur's work—and suggest the artist's deep engagement with depicting unfathomable spaces. These paintings shroud their mysterious subjects in mists and veils of pigment.

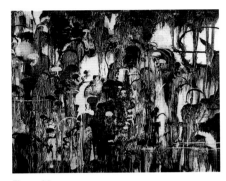

Figure 34
Michael Mazur
Dragon's Rockery I, 1997–98
Etching
Ed. 10
32 x 39 inches
Collection of the artist

114 Mazur explains that he was not thinking of the visual connections at the time and only later recalled the similarities to his work made thirty years prior. Michael Mazur, conversation with the author, Cambridge, MA, 6 February 2001.

In Mazur's most recent paintings, his attention has shifted away from the traditionalist art of Chao Meng-fu and the "spirit of antiquity." He has now looked to the eleventh-century Northern Song poet/painter/critic Kuo-Hsi, who studied under a Daoist master and was renowned for his inclination to "throw away what is old, and take in what is new."[115] The triptych *Fall Mountains for Kuo-Hsi,* 2001, bows to the Chinese master's methods for calling forth the potency of craggy mountain landscapes populated by twisted trees, and the format honors the tripartite construction of Chinese screens (plate 15). Kuo-Hsi played an important role in articulating the significance of the landscape in Chinese art. As was common at the time, he trained his son in the theory and practice of landscape art. The lessons of the father come down to us through the careful transcriptions made by the son during the years of apprenticeship. These teachings became a centerpiece of Fenollosa's thinking on Chinese art. He published an extended portion of the text in the first chapter of his book, *Epochs of Chinese and Japanese Art,* which has made the eleventh-century painter's ideas part of the twentieth- and twenty-first-century discourse in the United States on Chinese art.[116]

Kuo-Hsi addresses various specific subjects in his lessons such as rocks, mountains, and clouds, and laces his compositional advice with broader, more philosophically revealing elucidations. He talks about fundamentals for constructing paintings such as the "three

115 Ernest Fenollosa, *Epochs of Chinese and Japanese Art* (1913) (New York: Dover Publications, 1963), 13.

116 Fenollosa, *Epochs of Chinese and Japanese Art,* 12–19.

largenesses" involved in depicting landscapes: mountains, trees, and a man; the relative size of each will suggest the distances invoked in the painting.[117] A human figure, then, is the measure through which comprehension of the landscape's scale is made evident— it is also the entity through which we learn to relate to nature. "Mountains," he explains, "make water their blood: grass and trees their hair; mist and cloud their divine colouring....A mountain is a mighty thing, hence its shape ought to be high and steep, freely disposing itself like a man at ease, or standing up with grandeur, or crouching down like a farmer's boy...."[118] The human analogy persists in his discussion of the landscape. He extols the value of individuality for each landscape in human terms and emphasizes his perception of nature as animated with his constant pulmonary references.[119]

Mazur has studied Kuo-Hsi's paintings and drawn direct inspiration from them. In *Climbing the Mountain*, 2001, he honors both the paintings and the teachings of the Chinese painter (plate 16). Mazur's paint drips in thin veils or collects into thicker puddles at various points across the canvas. Forms seem to emerge and disappear. Throughout, there is a vertical organization of masses that float above one another without any visually established physical relationship. There is also a modeling of masses, to ambiguous ends, in Mazur's paintings that bears a resemblance to the Song painter's work. Most of these aspects were explained in Kuo-Hsi's lessons to his son. He taught that a mountain to be tall

117 "A mountain is larger than a tree, and a tree is larger than a man. A mountain at a certain distance, but not farther, becomes in size like a tree; the tree at that certain distance becomes the size of a man." Kuo-Hsi quoted in Fenollosa, *Epochs,* 17.

118 Ibid., 15–16.

119 He notes, for example, that, "High mountains have the blood-range lower down." Ibid.

must not be depicted in its entirety and in his paintings the tallest peaks show only their summits looming above the lower hills. Mists and water, he showed, should also play a dual role of revealing and obscuring. Mazur's latest paintings translate these teachings from the delicate mannerism of Kuo-Hsi's brushwork into the more gestural mark-making of twentieth-century abstract painting, but without abandoning the landscape as subject.

Throughout his career, Mazur has remained committed to the use of image in his work as this practice allows him to infuse his paintings with a poetic potency. His work refuses to divorce itself from the rich suggestive power of language. Part of the excitement that his paintings reflect about Chinese painting has to do with the latter's narrative allusiveness. As Kuo-Hsi told his son, "The ancient sages said that a poem is a painting without visible shape, and a painting is poetry put into form."[120] Mazur's paintings have always aspired likewise. He creates landscapes that do not relate directly to an observed location. His paintings are constructions based on constructions—contemplations on landscape art. They evoke the idea of place as the site one projects oneself into. In particular, Mazur's paintings offer the locus of spiritual awareness. The contrast between specifics and vagaries leads to contemplation of the particular and the universal, the notion of the individual and a collective whole. Like great poetry, Mazur's paintings suggest diverse thematic ranges by referencing a very selective group of images. Mark becomes tree, tree becomes forest, forest becomes nature, and nature becomes something none can show but many know.

120 Ibid., 19.

Conclusion: The Three Perfections and the Fifth Dimension

Several histories of Chinese painting relate the story of Cheng Ch'ien's gift to the emperor in Ch'ang-an in the middle of the eighth century. Cheng was a painter, calligrapher, and poet and the emperor, pleased with his gift, inscribed it with the words: "Cheng Ch'ien's Three Perfections."[121] The three modes of expression were given more or less equal value for over a thousand years in China. Though they do often appear on the same surface, painting, calligraphy, and poetry (even when found independently) have traditionally been considered jointly to be the highest forms of expression. While all three artists in this exhibition are painters absolutely, their paintings are here presented as relating as well to the Three Perfections of Chinese art.

Steir's waterfall paintings celebrate her medium. They relish in the independent physicality of the paint. Each painting traces the history of its own creation in the topography of its surface. Pigment covers large areas of canvas while other areas, usually directly below some tiny aberration in the material, remain untouched. The paint records the history of its own journey down the face of the painting. The paintings give viewers the sense that each one is in itself a macrocosm, a universe the creation of which is evidenced in the patterns of paint. Steir found her original connection to Asian aesthetics in the flung ink portions of landscape paintings. Her work incorporates the most overtly painterly aspects of the Chinese painting tradition, and stands metaphorically for that first perfection of Chinese art.

121 Sullivan, *The Three Perfections*, 7.

Marden started with calligraphy. Though he has undoubtedly moved far beyond his calligraphic sources in his more recent paintings, Marden's technique continues to benefit from the earliest work he based on Chinese art. His awareness of body position and how that relates to the quality of line stems from his study of the Chinese written form. He also works with the width of his lines and the thickness of the pigment in a manner reflective of calligraphic traditions. Though he chooses to forgo the praise for spontaneous gestures, and his paintings are the antithesis of an art made without reworking, Marden's paintings share with calligraphy a formal language based on the tension between surface and space rendered primarily with lines on planes. Marden, then, has also imported one of the Three Perfections into his art, learned much from his study of that art, and moved to new visual terrain, but not without holding on to lessons that he learned from his close encounters with calligraphy.

Mazur has been deeply engaged with poetry throughout his career. Indeed, his use of realism has consistently had more to do with evoking specific images as part of his visual poetry than for their own sake. He has never feared working on a par with language—he has in fact relished infusing his paintings with literary overtures. Images in Mazur's paintings act as words do in relation to sentences, or as lines to poems—each evoking some detail that derives poetic fulfillment as it relates to the other images. He also relishes the ambiguity of his images and the transitory meanings evoked as they shift from clouds to islands, raindrops to leaves, trees to people. In Chinese art Mazur has found an aesthetic source of encouragment for his painting's textual potential—for his poems without words.

In this essay we have covered but five of the six imperative questions asked of any historian. We know *where* these three artists have come from and to where they have traveled; we have learned *who* they are and *when* several of the key events in their lives occurred; we have discussed *what* they have done and *how* they have achieved such magnificent results in their paintings; but attempts at accounting for *why* these three artists have turned to Chinese art have been noticeably absent. This is, of course, a particularly risky area of speculation when addressing contemporary events; the lens of time has a way of clarifying more than it obfuscates. But, in this instance a hypothesis does emerge from examining the paintings that Steir, Marden, and Mazur have made in the last fifteen years.

We will recall that the foremost consideration for the success of the Three Perfections, both individually and collectively, in Chinese art is the "Spirit Resonance." Each of the artists in this exhibition has described their desire to infuse their paintings with that mysterious power that is typically encapsulated in the term "spiritual." In her book, *Empty and Full: The Language of Chinese Painting,* François Cheng elaborates on the importance of a spiritual interpretation of Chinese painting. She writes that most premodern Chinese paintings allude to the relationship between man and heaven by suggesting "a movement toward a symbiosis of time and space, and through that, toward a symbiosis of man and the universe."[122] "Taking this into account," Cheng continues, "we have grounds to speak of a kind of fifth dimension, beyond space and time, that represents emptiness. On this level, emptiness constitutes the basis of the pictorial

122 François Cheng, *Empty and Full: The Language of Chinese Painting* (Boston: Shambhala, 1994), 97.

universe, yet it also transcends this universe and carries it toward the original unity."[123] She goes on to concede the difficulty of describing in material terms how artists achieve these goals. Cheng argues that typically the invocation of emptiness, along with the scale discrepancies common to the work (huge mountain, tiny person, for example), are used to evoke a sense of the spiritual.

Marden, Mazur, and Steir hope that viewers who see their paintings understand the formal complexities at work and respond to the areas of color, lines, and textures in a viscerally positive manner, but they suspect that it is possible to create works of art that can go farther, that will suggest the "original unity" that Cheng discusses, and this is the primary reason for their attraction to Chinese art. Perhaps paintings can induce an experience beyond cognition, a metaphysical response that transcends comprehension and conversation—one that can only be intuited. Language becomes progressively impotent as we move from the physical realm to the metaphysical. We can describe in great detail the properties of paint and canvas. We can also transcribe with some accuracy what a painter does in terms of color, line, and texture. We can even relate textual references and narrative possibilities when we find them. Words begin to fail as we enter into the allusive terrain of any picture. Finally, words fail completely at evoking the purely irrational and this is, ultimately, the realm occupied by Marden's, Mazur's, and Steir's newer works. Their paintings operate in different formal arenas from one another and share only fleeting resemblances, but these artists are united in their goal to privilege the "Spirit Resonance" of their paintings, and in so doing have revitalized modern painting.

123 Ibid.

PLATES

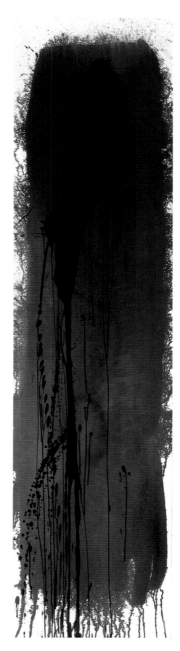

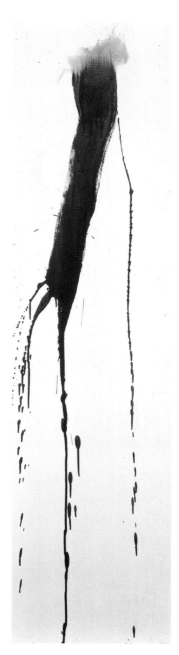

PLATE 1
Pat Steir
Winter Group XIII, 1991
Oil on canvas
67 1/2 x 17 inches
Collection of the artist

PLATE 2
Pat Steir
Winter Group VIII, 1991
Oil on canvas
67 1/2 x 17 inches
Collection of the artist

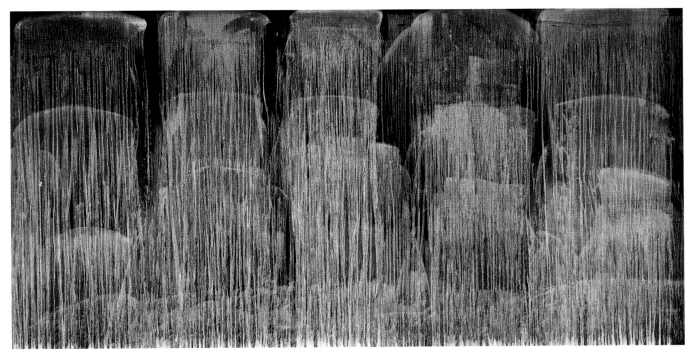

PLATE 3
Pat Steir
Sixteen Waterfalls of Dreams,
Memories, and Sentiment, 1990
Oil on canvas
78 1/2 x 151 1/8 inches
Collection of the artist

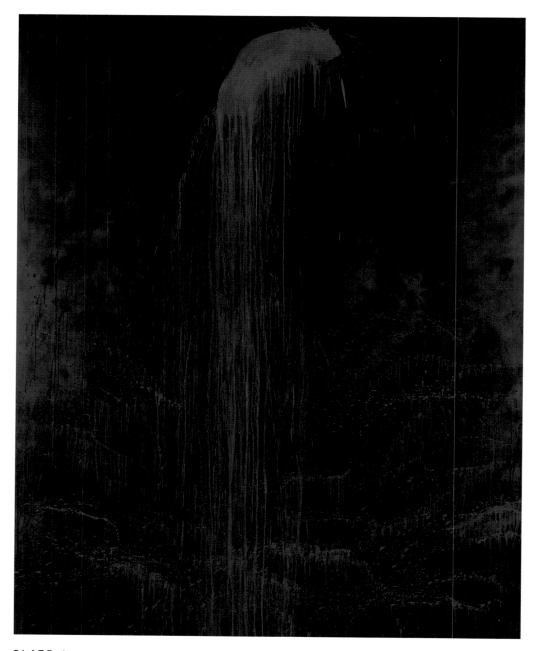

PLATE 4
Pat Steir
Outer Lhamo Waterfall, 1992
Oil on canvas
113 x 90 inches
Collection of the artist

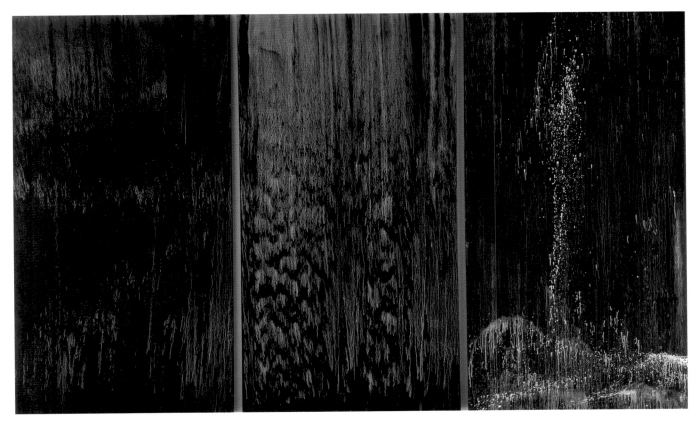

PLATE 5
Pat Steir
Foss, 1996–97
Oil on canvas
3 panels, each 102 x 54 inches
Collection of the artist

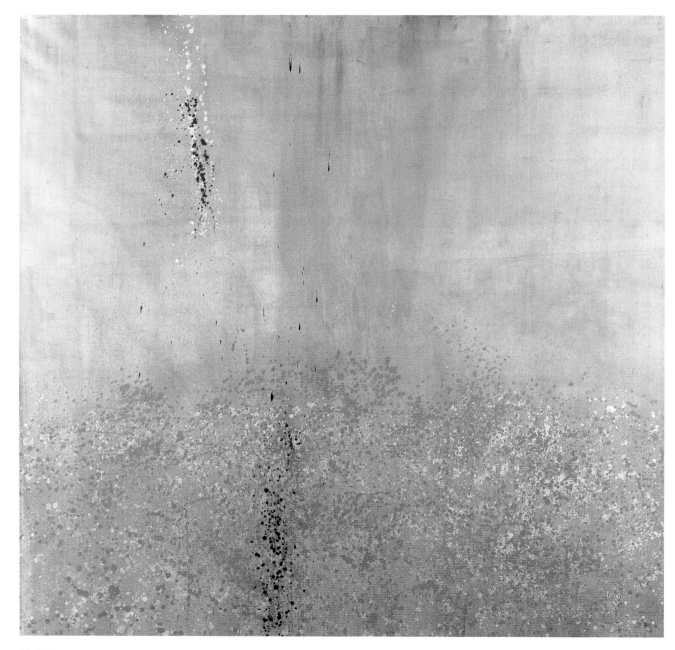

PLATE 6
Pat Steir
Nocturne in Blue and Silver, 1999
Oil on canvas
108 x 108 inches
Collection of the artist

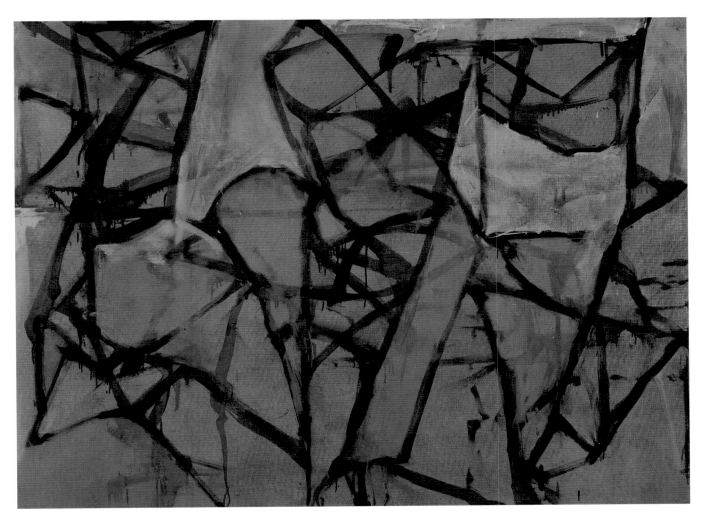

PLATE 7
Brice Marden
February, 1986
Oil on linen
36 x 48 inches
Collection of the artist

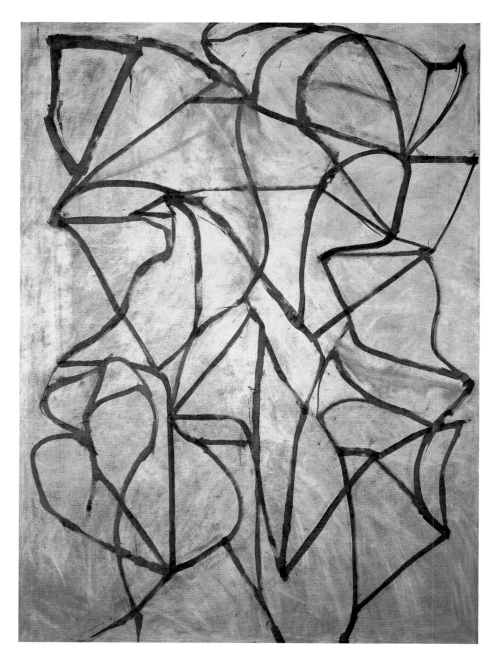

PLATE 8
Brice Marden
4 (Bone), 1987–88
Oil on linen
84 x 60 inches
Collection of Helen Marden

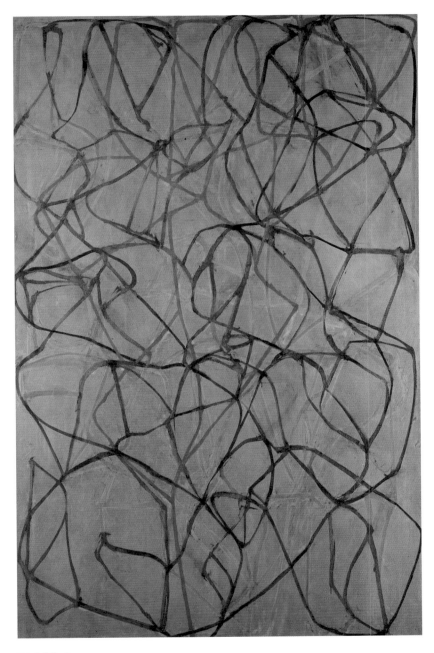

PLATE 9
Brice Marden
The Studio, 1990
Oil on linen
92 5/8 x 59 inches
Collection of the artist

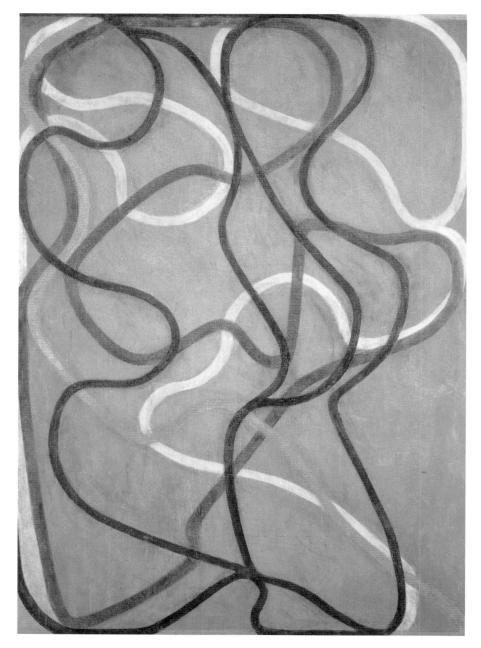

PLATE 10
Brice Marden
The Attended, 1996–99
Oil on linen
82 x 57 inches
Collection of the artist

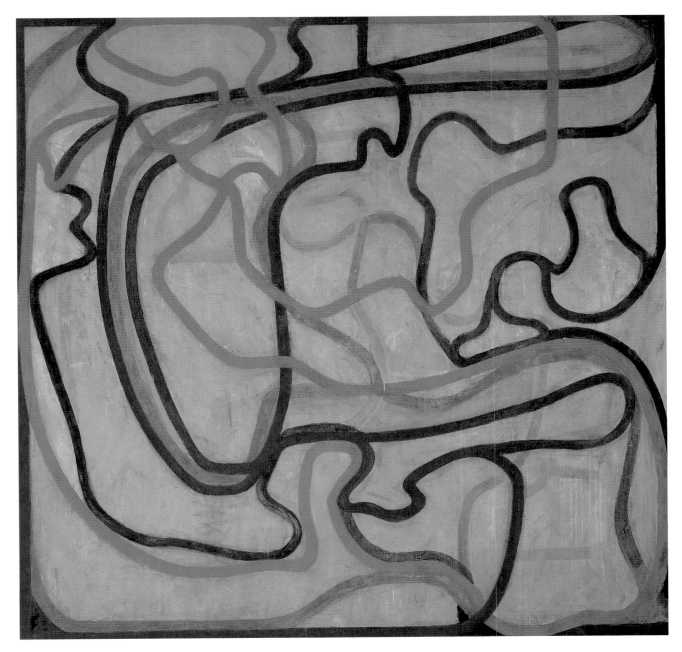

PLATE 11
Brice Marden
Epitaph Painting 3, 2001
Oil on linen
71 x 71 1/2 inches
Collection of the artist

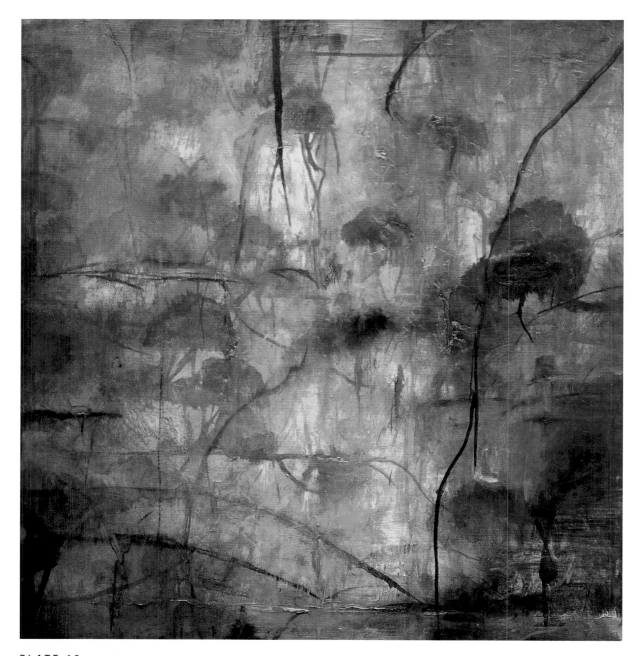

PLATE 12
Michael Mazur
After Chao Meng-fu, 1994
Oil on canvas
33 x 31 inches
Collection of Leif and Leah Larson, Cambridge, MA

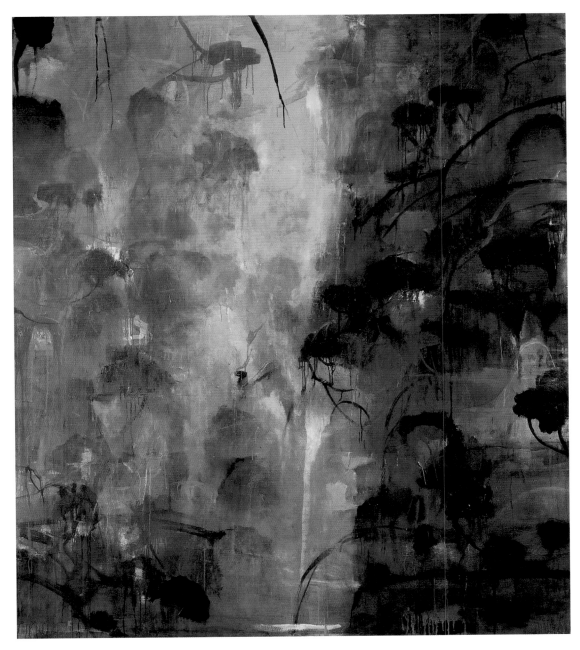

PLATE 13
Michael Mazur
After Chao Meng-fu, 1994
84 x 72 inches
Collection of Donald and Jeanne Stanton, Boston

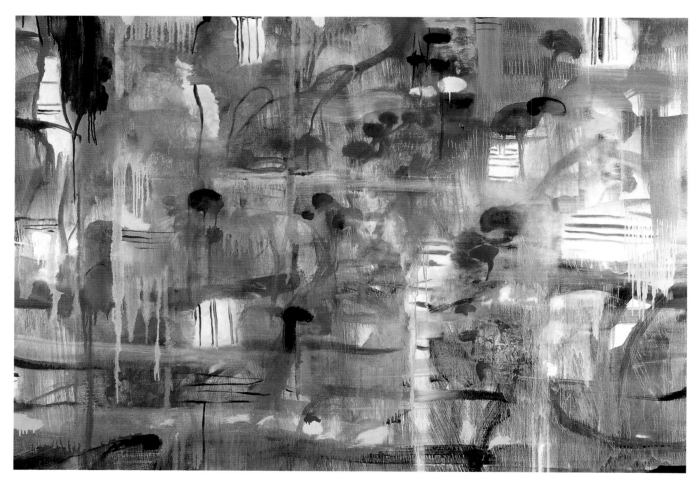

PLATE 14
Michael Mazur
Dragon's Rockery, 1997–98
Oil on canvas
60 x 80 inches
Collection of the artist

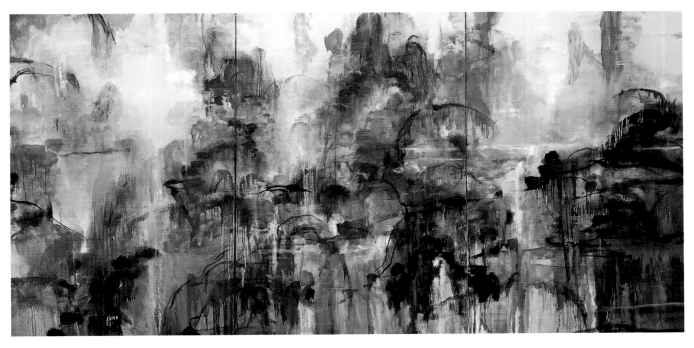

PLATE 15
Michael Mazur
Fall Mountains for Kuo-Hsi, 2001
Oil on canvas
72 x 144 inches
Collection of the artist

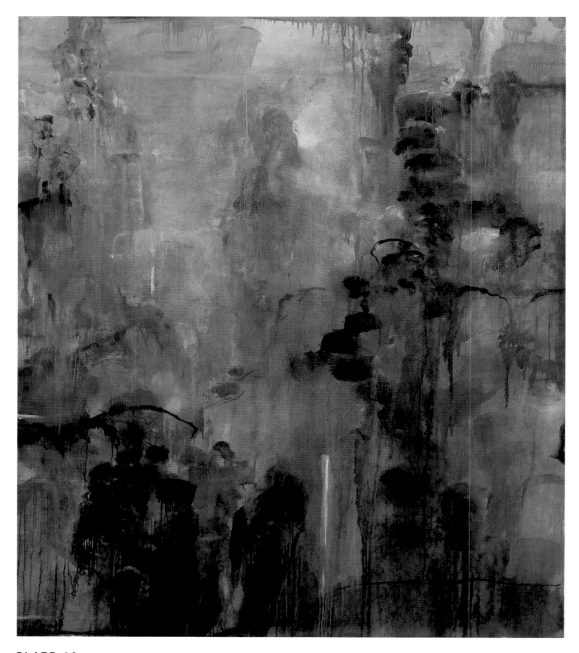

PLATE 16
Michael Mazur
Climbing in Mountains, 2001
Oil on canvas
60 x 72 inches
Collection of the artist

ABSTRACT EXPRESSIONISM AND THE "ZENBOOM"

Catherine L. Blais

The bringing together of recent works by American artists Brice Marden, Michael Mazur, and Pat Steir for the exhibition *Looking East: Brice Marden, Michael Mazur, and Pat Steir* at the Boston University Art Gallery invites the viewer to consider a source of inspiration that is common to these three contemporary painters. Over a period of about fifteen years, Marden, Mazur, and Steir have created paintings that witness a Western fascination with Asian cultures. Building upon that time frame, the exhibition puts in evidence the artists' sources of inspiration: for instance, Chinese poetry and calligraphy for Marden's project, the notion of wholeness in Zen philosophy for Mazur's project, and the tradition of Chinese landscape for Steir's project. From a formalist point of view, these artists seem to merge the gestural qualities of calligraphy with the abstraction and expressiveness that characterized post–World War II American painting. By shedding light on the affinities among these artists' respective projects, the exhibition raises questions about why Marden,

Mazur, and Steir came to develop an interest in Asian cultures. A previous generation of American abstract painters had already led the way for contemporary artists to look toward the East. (The term "looking East" refers to a Western point of view on Asian cultures.)

Asian cultures and the Abstract Expressionist legacy are two important sources in the art of Marden, Mazur, and Steir. The work of these three artists seems to blossom from the art of a previous generation of American Abstract Expressionists such as Al Leslie, Mark Tobey, Robert Motherwell, Franz Kline, and painters such as Agnes Martin and Ad Reinhardt. This generation of Abstract Expressionists was inspired by Zen philosophy, calligraphy, and other elements borrowed from Indian, Chinese, Japanese, or Southeast Asian cultures. The contemporary art of Marden, Mazur, and Steir conveys some similar preoccupations with Asian cultures. More specifically, they pursue and update a long tradition of Western artists inspired by Asian cultures in a quest to renew, enrich, and reinvent

their artistic production. Through their work, these three painters reflect the contemporary perception and appropriation of elements of Asian cultures in today's American society.

The contemporary impulse of Marden, Mazur, and Steir to "look East" takes place in an American painting tradition. Indeed, a parallel can be drawn between the production and the sources of inspiration of these three artists and the Abstract Expressionists. By drawing such a parallel, Marden, Mazur, and Steir are presented as American abstract painters inscribed in the lineage of their predecessors. Brice Marden once suggested: "I never saw a need to react against Abstract Expressionism….What I did was continuation."[1] Brice Marden was a young adult in the 1950s and like many artists of his generation, he learned about Abstract Expressionism, or what he himself refers to as the New York School, reading *ArtNews.*[2] Critics have consistently qualified the work of Steir as being "grounded in Abstract

Expressionism."[3] For instance, the gestural quality of Pat Steir's work was considered a "nod" to Abstract Expressionism in Lise Holst's *Art in America* exhibition review of 1990.[4] The artistic strategy of Mazur has been described as "to enact" the art of Abstract Expressionists.[5] Acknowledging such links with a recent past in American painting leads to a better understanding of the art of Marden, Mazur, and Steir and the social milieu in which they work.

The connection that existed between the Abstract Expressionists and a social phenomenon referred to as "Zenboom" in the United States of the 1950s catches a particular moment in time for the artistic impulse of "looking East." Considering that the art of the Abstract Expressionists was somehow representative of a fad in the American society as a whole, this essay prompts further reflection on how the art of Marden, Mazur, and Steir also speak of today's fascination for Asia and the importation of its cultures into the United States.

1 Phyllis Tuchman, "Behind the Lines," *Bostonia* (Spring 1998): 19.

2 Ibid., 17.

3 David Bourdon, "Pat Steir at Robert Miller," *Art in America* 83 (November 1995): 109.

4 Lise Holst, "Pat Steir at Robert Miller," *Art in America* 78 (December 1990): 165.

5 William Corbett, "Michael Mazur's New Painting 1997–1998," *Arts Media* (April 1998), 21.

Abstract Expressionists, the East, and America

As Ann Eden Gibson outlines in her wide-reaching study of the Abstract Expressionists, the movement as a whole, indeed New York School painting in general, was characterized by an "Asianness."[6] The art of Abstract Expressionists presents a fascination for Eastern cultures which is manifested not only in a formal borrowing, but also in the philosophy and approach to the act of creation. Mark Tobey, among others, was deeply influenced throughout his career by Asian cultures, and the 1950s was a period of "Zen rage" for him.[7] Robert Motherwell adopted an expressive Japanese brushstroke, and his art incorporated a synthesis of psychoanalysis and Zen teachings. Franz Kline developed an interest in the formal elements of calligraphy visible in his black expressive lines on white canvases. Ad Reinhardt stated that one of the greatest achievements in art and human history was "Zen painting."[8] In addition, Agnes Martin mentioned as her greatest inspiration the Chinese spiritual teachers.[9] Several painters were thus wrapped up in this "Asianness."

The Abstract Expressionists found in Asian visual cultures an alternative to some Western principles in art (mainly the abandonment of the illusionist tradition). The call for an intuitive method of artistic creation, formulated by the Zen master D. T. Suzuki during his stays in the United States, sparked several American artists of the 1950s. Abstract Expressionists found in Zen principles (spontaneity, intuitivity, and also control of the artist's environment) some of the essential elements they sought for their artistic projects. They adapted the vocabulary of calligraphy and Asian painting (gestural lines, traces of brushstroke, simplicity of shapes and colors, expression of an abstract world, unpainted surfaces, flatness) to their work, and perhaps more significantly they modified the Western approach to the act of creation. Thus, the art of Abstract Expressionists presented a response to Asian cultures manifested in the grammar rather than only in the vocabulary of their formal artistic language.[10]

6 Ann Eden Gibson, *Abstract Expressionism: Other Politics* (New Haven: Yale University Press, 1997), xxxv.

7 Helen Westgeest, *Zen in the Fifties: Interaction in Art between East and West* (Amsterdam: Waanders Uitgevers, 1996), 53.

8 Ibid., 67.

9 David J. Clarke, *The Influence of Oriental Thought on Postwar American Painting and Sculpture* (New York: Garland, 1988), 227.

10 Ibid., 23.

The Abstract Expressionists' inclination to borrow and to appropriate elements from Asian cultures was symptomatic of a social phenomenon manifest in post–World War II American society. Indeed, the fascination for Asian cultures permeated American society at large. Helen Westgeest, in her book on the interaction in art between East and West, outlines this dynamic and characterizes it as the "Zenboom."[11] Asian cultures and, by extension, elements that belong to these cultures such as Zen philosophy and calligraphy were increasingly trendy in the American society of the time. For instance, in 1957 an article in *The New Yorker* addressed the notion of "Zen" in a biography of the influential Zen master D. T. Suzuki.[12] In the magazine *Mademoiselle,* Nancy Wilson Ross asks *"What is Zen?"* Ross remarks that in the late 1950s, "Zen had meanwhile become an adjective for everything, varying from painting style to

personality types…it is now sprouting on all sides."[13] Trivial uses and appropriations of cultural elements borrowed from Asian societies were nevertheless hiding more serious motivations for looking East.

It is important to emphasize that the motivations for Americans to connect to Asian cultures in the 1950s are more numerous than unique. They appear rooted in certain key elements such as the American society's disillusionment; the shame and guilt toward the Chinese and Japanese people; the search for a renewed spirituality; and the curiosity for the culture of the Other.

"America," a poem written by Allen Ginsberg and published at the end of the 1950s, is a primary source that encapsulates the social and political context of the time.[14] Ginsberg expresses the Chinese problem, or the ghettoization of the Chinese Americans in the United States, and the American fear of a growing communism in Asia. He also implies the guilt caused by American atomic bombs

11 Helen Westgeest, *Zen in the Fifties,* 53.

12 Winthrop Sargeant, "Profiles: Great Simplicity," *The New Yorker* (August 31, 1957).

13 Nancy Wilson Ross, "What is Zen?" *Mademoiselle* 46 (January 1958), 65.

14 Allen Ginsberg, "America," *The Black Mountain Review* 3, no. 7 (Autumn 1957), 25–29.

that had targeted Japan not long before, and the situation of thousands of Japanese Americans who were placed in internment camps on the West Coast during World War II. His verse "Asia is rising against me" sets the tone to envision Asia as the Other for Americans. Moreover, Ginsberg offers a perspective on the reasons that drew Americans toward what he presents as an oppressed and annihilated Other, as he concludes in his diatribe to America: "Only the Zen Buddhists don't set up a counter-vibration." Shame and guilt toward Japanese and Chinese Americans might indeed have contributed to Americans' quest for redemption, or for a source of healing by establishing a contact with such Other.[15] Thus, for some Americans, as for Ginsberg, forms of philosophy and spirituality imported from Asia offered alternatives to fulfill the individual search for wholeness and promised a harmonious relationship of the individual with his environment.[16]

Although the United States of the 1950s was not exactly seeking a primitive and mythical exotic encounter, the appeal of unfamiliar cultures also accounted for such interest in Asia.[17] The East was exotic for the West to the extent that it embodied sophisticated cultures asserting differences with American culture. The will to obtain a realistic and updated image of Asian cultures, the need to compare a set of American values and conceptions, as well as mere curiosity should be added to the long list of motivations that led Americans to look East.

Bathed in a social milieu already turned toward Asian cultures for motivations that were deeply rooted in the American experience of World War II and the postwar period, the Abstract Expressionists did indeed look East. These painters were somehow influenced by the social and political context of the time and the fad in the American popular culture for "Zen" concepts, while the artists equally gave substance to the "Zenboom."

15 Jonathan D. Spence, *The Chan's Great Continent: China in the Western Minds* (New York: W.W. Norton, 1998), 166.

16 Rick Fields, *How the Swans Came to the Lake* (Boston: Shambhala, 1986), 205.

17 David J. Clarke, *The Influence of Oriental Thought on Postwar American Painting and Sculpture*, 22.

Brice Marden, Michael Mazur, and Pat Steir: The East and America

The Abstract Expressionists' artistic strategy of "looking East" offers a parallel to approach and discuss recent art by contemporary American painters Brice Marden, Michael Mazur, and Pat Steir. American artists from both generations have hybridized their pictorial product with elements appropriated from Asian cultures. However, Marden, Mazur, and Steir do not merely re-create the aesthetic of the Abstract Expressionists, they rather interpret and appropriate Asian cultures with a contemporary eye. Marden, Mazur, and Steir engage with Asian cultures, experiencing for themselves foreign cultural material. For instance, Michael Mazur studied the scroll painting of Chao Meng-fu, a thirteenth-century Chinese artist in order to produce his work.[18] Mazur's paintings in his *Mind Landscape After Chao Meng-fu* series (plates 12 and 13) attest to such influence; they also suggest through an abstracted vision of nature a "contemplative space," an "idea for painting" prompted by

Chao Meng-fu's work.[19] Also, Marden, Mazur, and Steir do not merely reinterpret the Abstract Expressionists' interpretation of Zen philosophy or calligraphy. They do not simply look back to the history of 1950s American painting to pursue their oeuvre. They build upon this model in order to produce contemporary paintings that foreground a 1950s artistic strategy of looking East.

Marden, Mazur, and Steir have created a pictorial product that should be considered as one of the most recent American artistic responses to Asian cultures. The artistic practice of Mazur is influenced by the quest for wholeness characteristic of Zen philosophy. His aim is to use art as a means of bringing the human mind and the natural world together. His paintings, such as *Dragon's Rockery* (plate 14), often refer to the essential aspects of landscape and nature (trees, rocks, and leaves) suggested through the use of short gestural lines, spontaneous broad strokes, and dripped paint.

18 Susan Danly and Rachel Rosenfield Lafo, *Branching: The Art of Michael Mazur* (Amherst: Mead Art Museum, 1997), 30.

19 Michael Mazur, *"Chao Meng-fu: the Mind Landscape of Hsieh Yu-yu," ArtNews* (November 1996), 85.

The work of Brice Marden is deeply influenced by the poetry of Chinese monks and calligraphy. His painting, *The Studio,* presents the artist's gestural fluidity and grace on canvas. As shown in *The Studio* (plate 9), Marden's paintings are webs of lines which capture the process of art-making, a sort of tribute to the calligraphic gesture. The pictorial plane, in most of Marden's works, is reminiscent of a repetitive process of painting, scraping, and repainting. Such addition of layers of paint on the canvas is a laborious task similar to the work, for instance, of Asian gardeners or calligraphers.

The project of Pat Steir displays awareness for the Chinese landscape tradition. The recurrent waterfall pattern, found for instance in *Outer Lhamo Waterfall* (plate 4), is suggested by dripped paint. Steir seemed inspired by some calligraphic splashes of ink seen on paper. Furthermore, this pattern refers to the importance of water and the theme of waterfalls prevalent in visual cultures from the East. She produces her art through a combination of control and randomness, of gesture and gravity.

As a common ground, these three artists allude to nature, recalling the tradition of landscape in Chinese painting. For instance, Steir's *Sixteen Waterfalls of Dreams, Memories, and Sentiment* (plate 3) and Mazur's *Fall Mountains for Kuo-Hsi* (plate 15) show gestural lines or drips that suggest with expressiveness and spontaneity the grandeur of nature, a concept at the core of such Chinese landscape tradition.

Marden, Mazur, and Steir stand as Western painters looking East and thus participate in a continuing American fascination with Asian cultures, even after the "Zenboom" has faded. The art of the Abstract Expressionists mirrored the "Zenboom" as much as it participated in creating that "Zenboom." Considering the recent art of Marden, Mazur, and Steir,

one may wonder what these contemporary paintings reveal about today's social and political context and the American motivations for looking East. The art of these three artists offers revelations about the present impulse to look East.

Now that guilt and shame toward the Asian populations have dissolved over time, the appeal for Americans to connect with certain aspects of Asian cultures is perhaps more rooted in a desire to renew their spirituality. When Marden referred to his paintings as "sounding boards for the spirit," such hypothesis seems plausible. As the notion of the Other evolves and is revealed as increasingly complex, Americans may also sense that the "field of the Other" in today's America is not necessarily elsewhere, somewhere East, but that it may as well be situated within a pluralist and multicultural American society.[20] As such, the expression of a will to look East may constitute for Americans a means to understand who they are in some baroque and hybrid aspects of their own culture and society. As contradictory as it seems, Americans may also want to preserve the modern conception of an exotic and different foreign and far-removed cultural entity that serves to contrast and enrich the American society.

Historical distance may confirm or disprove the veracity of this path of reflection which is offered here to stir further thoughts about the present motivations drawing Americans toward certain aspects of Asian cultures. The exhibition *Looking East: Brice Marden, Michael Mazur, and Pat Steir* gives an opportunity to deduce some of these motivations. Like the art of their predecessors that mirrored the "Zenboom," the paintings of Marden, Mazur, and Steir certainly touch on elements of the contemporary American society and its current fascination for looking East.[21]

20 Hal Foster points out some assumptions that shadow a complete understanding of the complex "field of the Other," in Hal Foster, *The Return of the Real* (Cambridge: MIT Press, 1996), 173.

21 The author acknowledges the financial support for her research in preparing this essay from the Social Sciences and Humanities Research Council of Canada and Fonds pour la Formation de Chercheurs et l'Aide à la Recherche.

EXHIBITION CHECKLIST

PAT STEIR

1. *The Winter Group XIII,* 1991
Oil on canvas
67 1/2 x 17 inches
Collection of the artist

2. *The Winter Group XVIII,* 1991
Oil on canvas
67 1/2 x 17 inches
Collection of the artist

3. *Sixteen Waterfalls of Dreams, Memories, and Sentiment,* 1990
Oil on canvas
78 1/2 x 151 1/8 inches
Collection of the artist

4. *Outer Lhamo Waterfall,* 1992
Oil on canvas
113 x 90 inches
Collection of the artist

5. *Foss,* 1996–97
Oil on canvas
3 panels, each 102 x 54 inches
Collection of the artist

6. *Nocturne in Blue and Silver,* 1999
Oil on canvas
108 x 108 inches
Collection of the artist

BRICE MARDEN

7. *February,* 1986
Oil on linen
36 x 48 inches
Collection of the artist

8. *4 (Bone),* 1987–88
Oil on linen
84 x 60 inches
Private collection of Helen Marden

9. *Epitaph Painting 3,* 2001
Oil on linen
71 x 71 1/2 inches
Collection of the artist

10. *The Studio,* 1990
Oil on linen
92 5/8 x 59 inches
Collection of the artist

11. *Study for Epitaph Painting 4,* 1998
Kremer ink and collage on Lanaquarelle paper
41 1/4 x 57 1/2 inches, overall
Collection of the artist

12. *The Attended,* 1996–99
Oil on linen
82 x 57 inches
Collection of the artist

MICHAEL MAZUR

13. *Oak II,* 1989
Monoprint on silk
32 x 32 inches
Collection of the artist

14. *Oak III,* 1989
Monoprint on silk
32 x 32 inches
Collection of the artist

15. *Oak V,* 1989
Monoprint on silk
32 x 32 inches
Collection of the artist

16. *After Chao Meng-fu,* 1994
Oil on canvas
33 x 31 inches
Collection of Leif and Leah Larson, Watertown, MA

17. *After Chao Meng-fu,* 1994
Oil on canvas
84 x 72 inches
Collection of Donald and Jeanne Stanton, Boston

18. *Dragon's Rockery,* 1997–98
Oil on canvas
60 x 80 inches
Collection of the artist

19. *Dragon's Rockery I,* 1997–98
Etching
Ed. 10
32 x 39 inches
Collection of the artist

20. *Fall Mountains for Kuo-Hsi,* 2001
Oil on canvas
72 x 144 inches
Collection of the artist

21. *Climbing in Mountains,* 2001
Oil on canvas
60 x 72 inches
Collection of the artist

ARTISTS' CHRONOLOGIES

BRICE MARDEN CHRONOLOGY

1938
Born in Bronxville, New York.

1958
Attended the Boston University School of Fine and Applied Arts.

1961
Attended Yale University's School of Art and Architecture (until 1963).

1963
Moves to the Lower East Side, New York, in the fall.

December 6–January 6, 1964: First one-man exhibition, *Brice Marden,* The Wilcox Gallery, Swarthmore College, Swarthmore, Pennsylvania.

1966
January 6–31: One-man exhibition in New York, *Brice Marden/Back Series,* Bykert Gallery, New York.

1969
September 25–October 25: One-man exhibition in France, *Brice Marden,* Galerie Yvon Lambert, Paris.

1970
January 17–February 7: Part of *21 Alumni,* a group exhibition at Boston University, School of Fine and Applied Arts, Boston.

January 30–February 15: One-man exhibition in Italy, *Brice Marden,* Françoise Lambert, Milan.

December 16–February 1, 1970: Part of *1969 Annual Exhibition: Contemporary American Painting,* Whitney Museum of American Art, New York.

1971
February 25–April 18: Part of *The Structure of Color,* Whitney Museum of American Art, New York.

May 18–June 7: One-man exhibition in Germany, *Brice Marden: Bilder und Zeichnungen,* Konrad Fischer, Düsseldorf.

1972
June 24–August 20: Part of *Seventieth American Exhibition,* The Art Institute of Chicago.

1973
January 10–March 18: Part of *1973 Biennial Exhibition: Contemporary American Art,* Whitney Museum of American Art, New York.

May 25–July 22: Part of *American Drawings 1963–1973,* Whitney Museum of American Art, New York.

1974
Part of *Some Recent American Art,* organized and circulated under the auspices of The International Council of The Museum of Modern Art, New York, and traveled to Australia and New Zealand.

January–February: Part of *Strata: Paintings, Drawings and Prints by Ellsworth Kelly, Brice Marden, Agnes Martin, Robert Ryman, and Cy Twombly,* Royal College of Art Galleries, London.

September 19–November 1: Part of *Continuing Abstraction in American Art,* Whitney Museum of Art, Downtown Branch, New York.

October 9–January 5, 1975: Part of *Eight Contemporary Artists,* The Museum of Modern Art, New York.

1975
Part of *Recent Drawings: William Allan, James Bishop, Vija Celmins, Brice Marden, Jim Nutt, Alan Saret, Pat Steir, Richard Tuttle,* circulated under the auspices of The American Federation of Arts, New York.

March 7–May 4: One-man exhibition at The Solomon R. Guggenheim Museum, New York, *Brice Marden.*

1976
June 16–September 5: Part of *A Selection of American Art: The Skowhegan School 1946–1976,* Institute of Contemporary Art, Boston, and traveled to the Colby Museum of Art, Waterville, Maine.

June 24–July 20: Part of *Three Decades of American Art Selected by the Whitney Museum,* Seibu Museum of Art, Tokyo.

1977
February 19–April 3: Part of *1977 Biennial Exhibition,* Whitney Museum of American Art, New York.

September 16–October 16: *Recent Gifts and Purchases,* The Solomon R. Guggenheim Museum, New York.

November 22–December 3: One-man exhibition in Greece, *Brice Marden: Etchings and Recent Drawings,* Jean & Karen Bernier, Athens.

1978
July 19–September 24: Part of *Art about Art,* Whitney Museum of American Art, and traveled.

1980
February 1–23: One-man exhibition in Japan, *Brice Marden: Paintings and Drawings,* Galerie Valeur, Nagoya.

1981
March 12–April 26: One-man exhibition in the Netherlands, *Brice Marden: Paintings, Drawings, Etchings 1975–80,* Stedelijk Museum, Amsterdam.

May 8–June 21: One-man exhibition in England, *Brice Marden: Paintings, Drawings and Prints 1975–80,* Whitechapel Art Gallery, London.

1982
May 5–July 11: Part of *Abstract Drawings, 1911–1981,* Whitney Museum of American Art, New York.

1984
April 1–May 16: Part of *The Meditative Surface,* The Renaissance Society at the University of Chicago.

1985
June 28–September 3: Part of *Painterly Visions, 1940–1984: The Guggenheim Museum Collection and Major Loans,* The Solomon R. Guggenheim Museum, New York.

1986
May 1–July 13: Part of *Sacred Images in Secular Art,* Whitney Museum of American Art, New York.

November 23–March 8, 1987: Part of *The Spiritual in Art: Abstract Painting 1890–1985,* Los Angeles County Museum of Art, Los Angeles, and traveled.

1988
February 4–March 13: Part of *Fifty Years of Collecting: An Anniversary Selection—Painting Since World War II: North America,* The Solomon R. Guggenheim Museum, New York.

1991
March 23–July 21: One-man exhibition at the Museum of Fine Arts, Boston, *Connections: Brice Marden.*

Brice Marden—Cold Mountain, Dia Center for the Arts, plus international tour.

1992
Part of *Allegories of Modernism: Contemporary Drawing,* The Museum of Modern Art, New York.

1993
Brice Marden, Kunstmuseum, Basel.

1998
Work Books, 1964–1995, Kunstmuseum Winterthur, Switzerland, plus international tour.

1999
Brice Marden: Work of the 90's, Dallas Museum of Art, plus national tour.

2000
Brice Marden, Serpentine Gallery, London.

2001
Boston University Alumni Award
Drawing the Line: A Retrospective of Drawings by Brice Marden, Maier Museum of Art, Lynchburg, VA.

MICHAEL MAZUR CHRONOLOGY

1935
Michael Burton Mazur born November 2 in New York.

1949
Assists artist Alan Ullman in Greenwich Village.

Takes painting classes with Morris Davidson.

1953–1954
Attends Amherst College.

Travels freshman year to Europe, incuding Venice and southern France. Reads Dante's *Inferno* in original Italian.

1954–1955
Takes classses from Leonard Baskin.

Works as intern in New York architectural offices of Ely Jacques Kahn and Robert Jacobs.

Attends Yale Summer School of Music and Art, Providence. Teaches here in later years.

1956
Lives in Italy.

Studies drawing at the Accademia di Belle Arti in Florence.

1958
Earns B.A. at Amherst College.

Marries Gail Beckwith.

Begins graduate studies at School of Art and Architecture, Yale University.

Works as teaching asistant for Gabor Peterdi and William Bailey.

1959
Receives B.F.A. from Yale University.

Son Daniel is born.

1960
Solo exhibition at Barone Art Gallery, New York.

1961
Receives M.F.A. from School of Art and Architecture, Yale University.

Begins to teach printmaking, life drawing, and anatomy at the Rhode Island School of Design.

Daughter Kathe is born.

Begins *Closed Ward* series, based on art therapy visits to Howard State Mental Facility, Providence.

1962
Receives Louis Comfort Tiffany Foundation Grant.

1964
Receives fellowship from the John Simon Guggenheim Foundation.

Focuses on sculpture.

Receives award from the American Academy of Arts and Letters.

1965
Completes *Images from a Locked Ward* portfolio of fourteen lithographs.

Begins teaching at Brandeis University, works there for next ten years.

1968
Publishes portfolio of intaglio prints entitled *The Artist and the Model.*

Receives a Tamarind Artist Fellowship and produces 34 editions of primarily black and white lithographs using *The Artist and the Model* theme.

Inspired by *Edgar Degas: Monotypes* to begin making monotypes.

1969
Good friend George Lockwood dies.

1970
Moves to New York City.

Becomes active in Art Workers Coalition.

Selected to exhibit at Venice Biennale, but withdraws in protest with several other artists as an antiwar boycott of American foreign policy.

1972–1973
Returns to Cambridge.

Is visiting professor at Yale University School of Art and Architecture and Queens College, Flushing, New York.

1974
Meets artist Mary Frank. Friendship includes joint work sessions.

Appointed to board of the Artists' Foundation in Boston.

Joins Terry Dintenfass Gallery, New York.

1975
Receives commission from the U.S. Department of the Interior to participate in bicentennial-year traveling exhibition, *America 1976.*

Guest teacher at College of Creative Studies, University of California, Santa Barbara.

Resigns from Brandeis to devote full time to art.

Joins Harcus Krakow Gallery, Boston.

1976
Visits Naum Gabo to view Gabo's wood-engraving monoprints with group of Museum of Fine Arts curators.

1977
Begins guest teaching printmaking classes at Harvard University.

Works with master printer Robert Townshead.

1978
Travels to France and Barcelona.

Documents and organizes ten portfolios of Gabo's wood-engraving monoprints and writes article on Gabo's monoprints for the *Print Collector's Newsletter.*

Becomes member of the Massachusetts State Art Council for a three-year term.

1979
Curates exhibition at MIT's Hayden Gallery.

Joins the Robert Miller Gallery, New York.

1980
Introduces Jim Dine to monotype techniques.

1982
Begins *Wakeby Day, Wakeby Night* series of monotypes commissioned by MIT.

Creates monotype series to illustrate Richard Howard's translation of *Les Fleurs du Mal* by Charles Baudelaire.

Guest teaches at Cornell University; SUNY, Purchase.

Teaches a class at the Graduate School of Art, Boston University.

1983
Begins ten-year service as member of Pennell Committee at the Library of Congress.

Designs sets and signs for the *El Salvador* oratorio concert by the Back Bay Chorale.

1984
Organizes Artists for a Nuclear Weapons Freeze project which he co-directs with Barbara Krakow.

His "Art for Arms Sake" satire published in *New York Times.*

1987
Studies Chinese landscape and garden traditions in China.

1988
Works on series of silk monotype screens.

1990
Founds New Provincetown Print Project in conjunction with the Fine Arts Work Center, Provincetown.

Collaborates on print projects and *Harvard Evenings* print series.

1992
Creates monotypes to accompany Robert Pinsky's translation of *The Inferno of Dante.*

Appointed to the Board of Trustees of the Fine Arts Work Center, Provincetown.

1993
Undergoes balloon angioplasty to treat heart disease.

1996
Joins Longpoint Gallery, Provincetown.

1997
Elected Chair of the Board of the Fine Arts Work Center, Provincetown.

Returns to Florence and Rome.

1998–1999
Collaborates on set design for adaptation of Dante's *Inferno.*

2000
L'Inferno: Illustrazione per L'Inferno di Dante, Castelvecchio, Verona, Italy, accompanying exhibition catalogue.

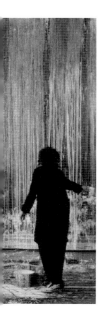

PAT STEIR CHRONOLOGY

1940
Iris Patricia Sukoneck born April 10 in Newark, NJ.

1956–1958
Attends Pratt Institute in Brooklyn, NY. Studies with Richard Lindner and Philip Guston.

1958–1960
Studies at Boston University.

1960–1962
Studies at Pratt Institute. Receives her B.F.A. in 1962.

1962–1966
Works as a book designer and illustrator.

1964
First exhibition at Terry Dintenfass Gallery, New York

1966–1971
Works as the art director for Harper & Row publishing company in New York. Travels to the southwestern United States. Repeatedly returns over the next few years.

Begins using a style emphasizing the brushstroke and the drip. The style also features grids, primary shapes, color charts, cancellation marks, and elements from typography and mechanical drawing. Works in this style include: *Altar* (1968–69), *Bird* (1969), *Looking for the Mountain* (1971), and *The Way to New Jersey* (1971).

1970
Meets Conceptual and Minimalist artists, John Baldessari, Sol LeWitt, Sylvia Mangold, Robert Mangold, and Lawrence Weiner.

1971–1973
Uses the black-square motif in her works, including *Breadfruit* (1973) and *Line Lima* (1973). Uses irises and birds to represent figures.

1972–1975
Teaches at the California Institute of the Arts.

Travels to Italy and France.

1973–1980
Focuses on works that analyze the process and history of painting; predominantly uses multi-panel formats. Still maintains the dripping brushstroke and cancellation marks.

Awarded by National Endowment for the Arts with Individual Artist's Grant.

Exhibits in Italy, France, and Switzerland for the first time.

1975–1978
Helps found and becomes board member of *Printed Matter* and *Heresies* magazines.

Becomes editor of *Semiotext*.

Travels extensively through the United States and Europe.

Creates first installation works in France.

1977–1978
Through a grant from the National Endowment for the Arts creates a series of installation works exhibited in Louisville, KY, Birmingham, AL, Oneonta, NY, and Dayton, OH.

1978–1982
Crown Point Press sponsors trip for thirteen artists to South Seas.

Meets John Cage.

Lives predominantly in Holland.

1980–1983
Becomes interested in Japanese art and calligraphy.

Travels to Japan and Hong Kong, where she makes her first woodcut.

Paints a series of twenty-three works in three-panel format, based on *Japonaiserie: The Tree* (1887), Vincent van Gogh's copy of Ando Hiroshige's *Plum Estate, Kamiedo* (1857).

Awarded a Guggenheim Fellowship.

1982
Draws *At Sea* series and paints *The Brueghel Series* (completed 1984).

1982–1984
Paints *The Brueghel Series*, based on Jan Brueghel the Elder's *Flowers in a Blue Vase* (1599). Executes two monochrome versions in sixteen panels each and a larger color version in sixty-four panels.

1984
Returns to Japan to make woodcuts.

Marries Joost Ellfers.

1985
Paints installation works *Mirages,* to be exhibited outdoors among trees.

Starts looking at Chinese art and calligraphy. Large version of *Brueghel Series* is acquired by the Kunstmuseum, Bern.

1985–1987
Includes waves in a number of paintings and drawings. Draws influence from Katsushika Hokusai, Ando Hiroshige, Leonardo da Vinci, J. M. W. Turner, and Gustave Courbet.

Paints tondo series, *The Moon and the Wave,* inspired by the works of a follower of Hokusai.

1987
Creates an installation at The Museum of Contemporary Art, New York entitled *Self-Portrait*. Re-creates *Self-Portrait* for eight other museums in Europe and Canada.

Travels to China to make series of woodcuts and monotypes.

1987–1988
Develops a series of black and silver waterfall paintings, beginning each with a single mark or throw of paint.

1989–1992
Solely uses monochromatic color schemes.

Pratt Institute awards Honorary Doctorate of Fine Arts.

Make a series of waterfall paintings each developed from one mark, with splash-ups in primary colors.

1992
Executes new *Mirages,* huge installation works on scrims, which are exhibited among trees at Documenta in Kassel, Germany.

Makes the installation *Heartline* in Grenoble; reworked the following year in Berlin.

1993
Represented in the 45th Biennale, Venice, Italy.

1993–1994
Paints work with a full color scheme.

2000
Dazzling Water: Dazzling Light by John Yau. Published with traveling exhibition.

2001
Boston University, School for the Arts, Distinguished Alumni Award

SELECTED BIBLIOGRAPHIES

BRICE MARDEN

Anthony d'Offay Gallery. *Brice Marden: Recent Paintings & Drawings*. Essay by John Yau. Exh. cat. London: Anthony d'Offay Gallery, 1988.

Ashbery, John. "Grey Eminence." *ArtNews* 71, no. 1 (March 1972): 26–27, 64–66.

Bann, Stephen. "Adriatics: à propos of Brice Marden." *20th Century Studies* no. 15/16 (December 1976): 116–29.

_____. "A Cold Coming: Brice Marden's Wager With Tradition." *Robert Lehman Lectures on Contemporary Art No 1*. Cooke, Lynne, and Karen Kelly, eds. New York: Dia Center for the Arts, 1996.

Caley, Shaun. "Brice Marden." *Flash Art* (International Edition) 135 (Summer 1987): 92.

"Conversation with Brice Marden." *Art Rite*, no. 9 (Spring 1975): 39–42.

Crimp, Douglas. *Opaque Painting*. Milan: Centro Comunitario di Brera, 1973.

Dickhoff, Wilfried. *Brice Marden*. Exh. cat. Köln: Michael Werner, 1989.

Fairbrother, Trevor. *Brice Marden: Boston*. (A Connections Project at the Museum of Fine Arts, Boston, 1991.) Contributions by Robert Creeley, Brice Marden, Patti Smith, and John Yau. Exh. cat. Boston: The Museum of Fine Arts, 1991.

Franz, Erich. *In Quest of the Absolute*. New York: Peter Blum Edition, 1996.

Fricke, Marion. "Brice Marden (Interview)." *Art Press* 17 (1996): 84–86.

Gagosian Gallery. *Brice Marden: The Grove Group*. Exh. cat. New York: Gagosian Gallery, 1991.

Galerie Montenay. *Brice Marden*. Essays by Jean-Claude Lebensztejn and Klaus Kertess. Exh. cat. Paris: Galerie Montenay, 1987.

Gardner, Paul. "Call it a Mid-Life Crisis." *ArtNews* 93 (April 1994): 140–43.

Gilbert-Rolfe, Jeremy. "Brice Marden's Paintings." *Artforum* 13, no. 2 (October 1974): 30–38.

Gilmour, Pat. "The Prints of Brice Marden." *Print Collector's Newsletter* 23 (May/June 1992): 49–52.

Hale, Niki. "Of a Classic Order: Brice Marden's Thira." *Arts Magazine* 55, no. 2 (October 1980): 152–53.

Hindry, Anne. "Brice Marden: l'orée du tableau." *Artstudio* (Summer 1986): 48–55.

Kertess, Klaus. *Brice Marden, Paintings and Drawings*. New York: H.N. Abrams, 1992.

Kunsthalle Bern. *Marden's Doubt*. Essay by Yve-Alain Bois. Exh. cat. Bern, Switzerland: Kunsthalle Bern, 1993.

Kunsthalle Palazzo. *Brice Marden. Samuel Buri/Ernst Messerli: Projekte für das Basler Münster*. Essay by Philip Ursprung. Exh. cat. Liestal: Kunsthalle Palazzo, 1990.

Kunstraum München. *Brice Marden: Drawings/Drawings 1964–1978*. Essays by Hermann Kern and Klaus Kertess. Exh. cat. München: Kunstraum München, 1979.

Kutner, Janet. "Brice Marden, David Novros, Mark Rothko: The Urge to Communicate through Non-Imagistic Painting." *Arts Magazine* 50, no. 1 (September 1975): 61–63.

Lee, Janie C. *Brice Marden Drawings: The Whitney Museum of American Art Collection*. New York: The Whitney Museum of American Art, distributed by H.N. Abrams, 1998.

Lewison, Jeremy. *Brice Marden: Prints 1961–1991. A Catalogue Raisonné*. London: The Tate Gallery, 1992.

Liebmann, Lisa. "Brice Marden: The 'Duse' of Minimalism." *Parkett*, no. 7 (1986): 37–44.

Lippard, Lucy R. "The Silent Art." *Art in America* 55, no. 1 (January–February 1967): 58–63.

Loock, Ulrich. "Brice Marden–Plane Image." *Artis* (Nov 1989): 30–35.

Mahoney, Robert. "Brice Marden: This is What Things are About." *Flash Art* (International Edition) 155 (November/December 1990): 116–20.

Mann, Cecile N. "An Interview with Brice Marden." *Artweek* 4, no. 12 (1976): 15–16.

Marden, Brice. *Cold Mountain Studies*. Text by Heiner Bastian. Munich: Schirmer/Mosel, 1991.

_____. *Brice Marden, Paintings, Drawings and Prints 1957–80*. London: Trustees of the Whitechapel Art Gallery, 1981.

_____. *Reporters Notebook: Drawings Made in Greece, Summer 1981*. New York: Pace Gallery Publications, 1984.

_____. "Three Deliberate Grays for Jasper Johns." *Art Now: New York* 3, no. 1 (March 1971).

_____. *Zeichnungen 1964–1978*. München, Germany: Kunstraum, 1979.

Margo Leavin Gallery. *Jasper Johns/Brice Marden/Terry Winters: Drawings*. Essay by Jeremy Gilbert-Rolfe. Exh. cat. Los Angeles: Margo Leavin Gallery, 1992.

Mary Boone/Michael Werner Gallery. *Brice Marden: New Paintings*. Essay by Peter Schjeldahl. Exh. cat. New York: Mary Boone/Michael Werner Gallery, 1987.

Matthew Marks Gallery. *Brice Marden*. Essay by David Rimanelli. Exh. cat. New York: Matthew Marks Gallery, 1995.

_____. *Brice Marden: Paintings, Drawings, Etchings*. Exh. cat. New York: Matthew Marks Gallery, 1993.

_____. *Brice Marden: Recent Drawings and Etchings*. Interview by Pat Steir. Exh. cat. New York: Matthew Marks Gallery, 1991.

Meyer, Franz. "Brice Marden's Glasmalerei-Entwürfe." *Parkett*, no. 7 (1986): 44–49.

Nodelman, Sheldon. *Marden, Novros, Rothko: Painting in the Age of Actuality*. Houston: Institute for the Arts, Rice University, 1978.

Öffentliche Kunstsammlung Basel. *Brice Marden*. Essay by Dieter Koepplin. Exh. cat. Basel: Öffentliche Kunstsammlung Basel, Museum für Gegenwartskunst, 1993.

Ostrow, Saul. "Brice Marden (Interview)." *BOMB* (Winter 1988).

The Pace Gallery. *Brice Marden: Marbles, Paintings and Drawings*. Essay by William Zimmer. Exh. cat. New York: The Pace Gallery, 1982.

_____. *Brice Marden: Recent Paintings and Drawings*. Essay by Jean-Claude Lebensztejn. Exh. cat. New York: The Pace Gallery, 1978.

_____. *Brice Marden: Recent Works*. Essay by Brice Marden. Exh. cat. New York: The Pace Gallery, 1984.

PaceWildenstein. *Brice Marden: Drawings 1964–1994*. Exh. cat. New York: PaceWildenstein, 1995.

Pellizzi, Francesco. "For Brice Marden: Twelve Fragments on Surface (and Some Afterthoughts)." *Parkett*, no. 7 (1986): 50–63.

Pincus-Witten, Robert. "Ryman, Marden, Manzoni: Theory, Sensibility, Meditation. *Artforum* 10, no. 10 (June 1972): 50–53.

Poirier, Maurice. "Color-Coded Mysteries." *ArtNews* 84 (January 1985): 52–61.

Poirier, Maurice and Jane Necol. "The '60s in Abstract: 13 Statements and an Essay." *Art in America* 71, no. 9 (October 1983): 122–23.

Price, Aimée Brown. "Artist's Dialogue: A Conversation with Brice Marden." *Architectural Digest*, May 1983, 54–60.

Ratcliff, Carter. "Abstract Painting, Specific Space: Novros and Marden in Houston." *Art in America* 63, no. 5 (September/October 1975): 84–88.

_____. "Mostly Monochrome." *Art in America* 69, no. 4 (April 1981): 111–31.

_____. "How to Study the Paintings of Brice Marden." *Parkett,* no. 7 (1986): 22–36.

_____. "Once More, With Feeling." *ArtNews* 71, no. 4 (Summer 1972): 35–37, 67–69.

Ricard, Rene. "An Art of Regret." *Artforum* 23 (Summer 1985): 86–91.

Richardson, Brenda. *Brice Marden.* New York: Dia Center for the Arts and Houston: Houston Fine Arts Press, forthcoming.

_____. *Brice Marden: Cold Mountain.* Houston: Houston Fine Art Press, 1992.

Rosenstein, Harris. "Total and Complex: Three Young Colorists." *ArtNews* 66, no. 3 (May 1967): 52–54, 67–68.

Schwabsky, Barry. "Brice Marden." *Artforum* 34 (January 1996): 80.

Schwarz, Dieter and Michael Semff, eds. *Brice Marden Workbooks, 1964–1995.* Düsseldorf: Richter, 1997.

Sharp, Willoughby. "Points of View: A Taped Conversation with Four Painters." *Arts Magazine* 45, no. 3 (December 1970/January 1971): 41–42.

Smith, Roberta. "Brice Marden's Paintings." *Arts Magazine* 47, no. 7 (May/June 1973): 36–41.

The Solomon R. Guggenheim Foundation. *Brice Marden.* Text by Linda Shearer. Exh. cat. New York: The Solomon R. Guggenheim Foundation, 1975.

Storr, Robert. "Brice Marden: Double Vision." *Art in America* 73 (March 1985): 118–25.

Taylor, Paul. "Marden's Metamorphosis." *Connoisseur* 221 (October 1991): 20–22.

Thomas Ammann Fine Art. *Brice Marden.* Text by Brice Marden. Exh. cat. Zürich: Thomas Ammann Fine Art, 1996.

Westfall, Stephen. "Marden's Web." *Art in America* 80 (March 1992): 94–99.

Whitechapel Art Gallery. *Brice Marden: Paintings, Drawings and Prints 1975–80.* Essays by Nicholas Serota, Stephen Bann, Roberta Smith, and Brice Marden. Exh. cat. London: Whitechapel Art Gallery, 1981.

Wylie, Charles. "Brice Marden: *Uxmal,* 1991–1993." *St. Louis Art Museum Bulletin* 21 (Winter 1995): 32–33.

Yau, John. "Brice Marden." *Flash Art* (International Edition) 142 (October 1988): 92–95.

MICHAEL MAZUR

Albright-Knox Art Gallery. *Master Prints from Upstate New York Museums* (Traveling Exhibition). Exh. cat. Buffalo, NY: Albright-Knox Art Gallery, 1995.

The Art Museum at Florida International University. *American Art Today: Night Paintings.* Exh. cat. Miami, FL: The Art Museum at Florida International University, 1995.

The Arts Club of Chicago. *Michael Mazur.* Exh. cat. Chicago: The Arts Club of Chicago, 1985.

Baudelaire, Charles. *Les Fleurs du Mal.* Translated by Richard Howard. Illustrated by Michael Mazur. Boston: David R. Godine, 1982.

Brockton Art Center. *Michael Mazur: Vision of a Draughtsman.* Exh. cat. Brockton, MA: Brockton Art Center-Fuller Memorial, 1976.

Brooklyn Museum of Art. *The American Artists as Printmaker.* Essay by Barry Walker. Exh. cat. Brooklyn, NY: The Brooklyn Museum, 1983–84.

Canaday, John. "Art For Sake of Expression, Not Esthetic Theory." *New York Times,* 5 March 1966, 23.

_____. "Michael Mazur Shifts Direction." *New York Times,* 27 November 1971, 21.

The Chrysler Museum. *Contemporary Monotypes.* Essay by Rodger Closby. Exh. cat. Norfolk, VA: The Chrysler Museum, 1985.

Corbett, William. "Michael Mazur's New Work." *Arts* 59 (January 1985): 114–15.

Divver, Barbara. "Michael Mazur." *Arts* 53 (May 1980): 2.

Dunham, Judith. *The Monumental Image: Prints by Jennifer Barlett, Chuck Close, Michael Mazur, Susan Rothenberg, Donald Sultan, Terry Winters.* Exh. cat. Northridge, CA: California State University and Sonoma State University, 1987.

DeCordova Museum. *Candid Painting: American Genre Painting 1950–1975.* Essay by Eva Jacob. Exh. cat. Lincoln, MA: DeCordova Museum, 1975.

_____. *Expressionism in Boston 1945–1985.* Essays by Theodore F. Wolff and Pamela Edwards Allara. Exh. cat. Lincoln, MA: DeCordova Museum, 1986.

Finch College Museum of Art. *Two Aspects of Illusion: Paul Gedeohn/Michael Mazur.* Introduction by Elayne H. Varian. Exh. cat. New York: Finch College Museum of Art, 1971.

Florescu, Michael. "Michael Mazur." *Arts* 52 (March 1978): 7.

Forman, Debbie. "Landscapes of the Mind." *Cape Cod Times,* 20 July 1996.

Fort Wayne Museum of Art. *Collection Selections, 1987:* Also *Earthly Delights: Garden Imagery in Contemporary Art.* Essay by Anna C. Knoll. Exh. cat. Fort Wayne, IN: Fort Wayne Museum of Art, 1987.

Genesis. Translated by Robert Alter. Frontispiece by Michael Mazur. San Francisco: Arion Press, 1996.

Glueck, Grace. "Michael Mazur." *New York Times,* 28 January 1977, C16.

_____. "Michael Mazur." *New York Times,* 25 November 1983, C17.

Goldman, Judith. *American Prints: Process and Proofs.* Exh. cat. New York: Whitney Museum of American Art, 1981.

Goodman, Linda. "Light Out of Darkness: Michael Mazur's Infernal Monotypes." *California Printmaker* 1 (April 1995): 4–7.

Goodyear, Frank Jr. *Perspectives on Contemporary Realism: Works on Paper from the Collection of Jalane and Richard Davidson.* Exh. cat. Philadelphia: Pennsylvania Academy of The Fine Arts, 1982.

Hayden Gallery. *The Narrative Impulse: Paintings, Drawings, and Monotypes: Robert Birmelin, Mary Frank, Michael Mazur, and Irving Petlin.* Exh. cat. Cambridge: Hayden Gallery, Massachusetts Institute of Technology, 1979.

_____. *Wakeby Day/Wakeby Night: Monumental Monotypes by Michael Mazur: A Documentation of the Commission for MIT.* Essays by Eugenia Parry Janis and Katy Kline. Exh. cat. Cambridge: Hayden Gallery, Massachusetts Institute of Technology, 1983.

Independent Curators Incorporated. "After Matisse, a Traveling Exhibition to the Phillips Collection." Essays by Tiffany Bell, Dore Ashton, and Irving Sandler. Exh. cat. Worcester, MA: Worcester Museum, 1986.

International Exhibitions Foundation. *Twentieth Century American Drawings—The Figure in Context.* Essay by Paul Cummings. Exh. cat. 1984.

Janus Gallery. *The Cyclamen Dance Series: An Exhibition of Paintings, Pastels, and Monotypes.* Exh. cat. Los Angeles: Janus Gallery, 1982.

Koslow, Francine Amy. *Henry David Thoreau as a Source for Artistic Inspiration.* Exh. cat. Lincoln, MA: DeCordova Museum, 1988.

Macalester College. *Michael Mazur—Painting, Prints, Drawings, Monotypes, 1962–88.* Essay by Cherie Doyle Reisenberg. Exh. cat. St. Paul, MN: Macalester College, 1988.

Marble, Melinda. *Herna: A Story.* Illustrated by Michael Mazur. Cambridge, MA: Bow and Arrow Press, 1993.

Mary Ryan Gallery. *Michael Mazur: Recent Paintings.* Essay by David Shapiro. Exh. cat. New York: Mary Ryan Gallery, 1996.

_____. *Michael Mazur.* Exh. cat. New York: Mary Ryan Gallery, 1990.

Massachusetts College of Art. *The Tree Show.* Essay by Norman Keys, Jr. Exh. cat. Boston: Massachusetts College of Art, 1987.

Mazur, Michael. "The Case for Cassatt." *Print Collector's Newsletter* 20 (January–February 1990): 197–201.

_____. "The Foundation for True 'Renaissance' in Printmaking." *Rhode Island School of Design Alumni Bulletin.* (June 1964): 16–19.

_____. "Looking at Art: The Mind Landscape of Hsieh Yu-yu." *ArtNews* 95 (November 1996): 84–85.

_____. "Monoprints of Naum Gabo." *Print Collector's Newsletter* 9 (November–December 1978): 148–51.

_____. "Monotype: An Artist's View." *The Painterly Print: Monotypes from the Seventeenth to Twentieth Century.* Essays by Sue Welsh Reed, Eugenia Parry Janis, Barbara Stern Shapiro, David W. Kiehl, Colta Ives, and Michael Mazur. Exh. cat. New York: The Metropolitan Museum of Art, 1980.

_____. "A Work that Marries Painting and Poetry." *Boston Globe,* 3 October 1982.

"Michael Mazur." *Artist's Proof* 10 (1970): 19–29.

Mead Art Museum and DeCordova Museum. *Branching: The Art of Michael Mazur.* Introduction by Robert Pinsky. Essays by Susan Danly and Rachel Rosenfeld Lafo. Exh. cat. Amherst, MA: Mead Art Museum, 1997.

Mecklenburg, Virginia M. *Modern American Realism: The Sarah Roby Foundation Collection.* Exh. cat. Washington, DC: National Museum of American Art, 1987.

Moffett, Kenworth and Clifford S. Ackley. *New England Works on Paper.* Exh. cat. Boston: The Museum of Fine Arts, 1977.

Moser, Joann. *Singular Impressions: The Monotype in America.* Exh. cat. Washington, DC: The Smithsonian Institution Press for the National Museum of American Art, 1997.

Museum of Art. *The Call of the Wild: Animal Themes in Contemporary Art.* Exh. cat. Providence: Rhode Island School of Design, 1987.

Museum of Fine Arts, Boston. *70's into 80's—Printmaking Now.* Essay by Clifford S. Ackley. Exh. cat. Boston: The Museum of Fine Arts, 1987.

_____. *Boston Collect—Contemporary Painting and Sculpture.* Essays by Theodore Stebbins and Judy Hoos Fox. Exh. cat. Boston: The Museum of Fine Arts, 1987.

_____. *The Unique Print 70's into 80's.* Essay by Clifford S. Ackley. Exh. cat. Boston: The Museum of Fine Arts, 1990.

The Museum of Fine Arts, Boston, and Williams College Museum of Art. *The Modern Art of the Print—Selections from the Torf Collection.* Essays by Clifford S. Ackley, Thomas Krens, and Deborah Menaker. Exh. cat. Boston: The Museum of Fine Arts, 1984.

The Museum of Modern Art. *Tamarind: Homage to Lithography.* Essay by Virginia Allen. Exh. cat. New York: The Museum of Modern Art, 1969.

The National Academy of Design. *Realism Today, American Drawings from the Rich Collection.* Essay by John I. H. Bauer. Exh. cat. New York: The National Academy of Design, 1988.

The National Gallery of Art. *The 1980's—Prints from the Collection of Joshua P. Smith.* Edited by Ruth Fine. Essay by Charles M. Ritchie. Exh. cat. Washington, DC: The National Gallery of Art, 1990.

New Jersey Center for Visual Arts. *The Combination Print 1980's.* Essay by Barry Walker. Exh. cat. Summit, NJ: New Jersey Center for Visual Arts, 1988.

Philadelphia Museum of Art. *New Art on Paper, The Hunt Manufacturing Co. Collection, Ann Percy.* Essay by Ellen Jacobwitz. Exh. cat. Philadelphia: Philadelphia Museum of Art, 1988.

Pinker Art Gallery. *Michael Mazur.* Introduction by Edward Bryant. Exh. cat. Hamilton, NY: Picker Art Gallery, Colgate University, 1973.

Pinsky, Robert. *The Want Bone.* Hopewell, NJ: Ecco Press, 1990.

_____. *The Inferno of Dante: A New Verse Translation.* Bilingual Edition. Illustrated by Michael Mazur. New York: Farrar, Straus and Giroux, 1994.

Rijksakademie van Beeldende Kunsten. *Contemporary American Graphic Artists.* Essay by Una E. Johnson. Exh. cat. Amsterdam: Rijksakademie van Beeldende Kunsten, 1968.

Rose Art Museum. *The Herbert W. Plimpton Collection of Realist Art.* Exh. cat. Waltham, MA: Rose Art Museum, Brandeis University, 1995.

_____. *Prints by Michael Mazur.* Essay by Russell Connor. Exh. cat. Waltham, MA: Rose Art Museum, Brandeis University, 1969.

Rutgers University Art Gallery. *Michael Mazur.* Exh. brochure. New Brunswick, NJ: Rutgers University Art Gallery, 1981.

The San Francisco Museum of Modern Art. *American Realism: Twentieth-Century Drawings and Watercolors from the Janus Collection.* Essay by Alvin Martin. Exh. cat. San Francisco: The San Francisco Museum of Modern Art, 1986.

Sandback, Amy Baker. "Not Fully Repeatable Information: Michael Mazur and Monotypes, An Interview." *Print Collector's Newsletter* 21 (November–December 1990): 180–81.

Silver, Joanne. "Mazur's Inferno." *Boston Herald,* 22 September 1995.

Stanford University Museum of Art. *The Anderson Collection—Two Decades of American Art.* Essay by Betsy Fryberger. Exh. cat. Stanford, CA: Stanford University, 1987.

Stapen, Nancy. "Amid High Technology, Artists Seek the Elemental." *Boston Globe,* 27 December 1990, 65–66.

_____. "A Mature Painter Branches Out." *Boston Globe,* 24 June 1993, 55.

_____. "Michael Mazur: Interpreting Hell." *ArtNews* 94 (November 1995): 103.

Storr, Robert. "East Coast: Michael Mazur." *New Art Examiner* (Chicago) 8 (December 1980): 17.

Tamarind Lithography Workshop, Inc., Catalogue Raisonné, 1960–1970. Albuquerque: University of New Mexico Art Museum, 1989.

Taylor, Robert. "Michael Mazur Monotypes a Breakthrough." *Boston Globe,* 20 March 1983, 49.

Townsend Center for the Humanities. *Image and Text: A Dialogue with Robert Pinsky and Michael Mazur.* Berkeley: Townsend Center for the Humanities, University of California, 1994.

Tuttman, Kathe. "Michael Mazur: Artist in Transition." *New Boston Review* (Winter 1975): 14–15.

University of Iowa Museum of Art. *Monotypes by Michael Mazur: The Inferno.* (Traveling Exhibition). Essays by Stephen Prokopoff, Michael Mazur, and Robert Pinsky. Exh. cat. Iowa City: University of Iowa, 1994.

Walker, Barry. *Michael Mazur's Self-Portraits.* Exh. cat. New York: Joe Fawbush Editions, 1987.

_____. "The Single State." *ArtNews* 83 (March 1984): 60–65.

Weisberg, Ruth. "Michael Mazur: Affirming the Idyll." *Artweek* 13 (3 July 1982): 1.

Wellesley College Museum. *Wellesley Greenhouse: Janowitz, Kumler, Mazur.* Exh. brochure. Wellesley, MA: Wellesley College Museum, 1977.

Whitney Museum of American Art. *The American Landscape: Recent Developments.* Statement by Michael Mazur. Exh. cat. Stamford, CT: Whitney Museum of American Art, 1981.

_____. *With the Grain—Contemporary Panel Painting.* Essay by Roni Feinstein. Exh. cat. Stamford, CT: Whitney Museum of American Art, 1990.

Williams College Museum of Art. *Fifty American Works on Paper from the Collection of Mr. and Mrs. Stephen D. Paine.* Essays by Hiram Carruthers Butler, et al. Exh. cat. Williamstown, MA: Williams College, 1979.

Wilson, Douglas C. "Hours Without Time: Michael Mazur Talks About Painting." *Amherst* 50 (Fall 1997): 10–18.

Zimmerli Art Museum. *The Prints of Michael Mazur: A Catalogue Raisonné.* Essays by Trudy V. Hansen, Barry Walker, Clifford S. Ackley, and Lloyd Schwartz. New Brunswick, NJ: Zimmerli Art Museum, Rutgers University, 2000.

PAT STEIR

Andre, Michael. "Pat Steir." *ArtNews* 74, no. 6 (Summer 1975): 144.

_____. "Pat Steir." *ArtNews* 75, no. 7 (September 1976): 68–69.

Aziz, Anthony. "Borrowing Beyond Appropriation." *Artweek* 20 (4 March 1989): 5.

Baker, Kenneth. "Pat Steir." *Arts Magazine* 49, no. 8 (April 1975): 21.

Boorsch, Suzanne. "New Editions: Pat Steir." *ArtNews* 77, no. 3 (March 1978): 137.

Braff, Phyllis. "Applying Original Ideas to Canvas." *New York Times,* 27 June 1993.

Brenson, Michael. "Flowering Plum: Chinese Motif for the Passing of Beauty." *New York Times,* 2 June 1985.

_____. "Why Asian Culture Answers the Needs of Western Artists." *New York Times,* 20 April 1986.

Brown, Gordon. "Pat Steir: Paley & Lowe." *Arts Magazine* 45, no. 4 (February 1971): 65–66.

Buonagurio, Edgar. "Artists' Books and Notations." *Arts Magazine* 53, no. 3 (November 1978): 5.

Campbell, Lawrence. "Pat Steir." *ArtNews* 63, no. 7 (November 1964): 22.

Castle, Frederick Ted. "Pat Steir and the Science of the Admirable." *Artforum* 20, no. 9 (May 1982): 47–55.

_____. "Pat Steir: Ways of Marking." *Art in America* 72 (Summer 1984): 124–29

Chadwick, Whitney. *Women, Art, and Society.* New York: Thames & Hudson, 1990.

Champey, Ines. "Pat Steir." *Art Press,* no. 67 (February 1983).

Cohrs, Timothy. "Pat Steir." *Arts Magazine* 60, no. 9 (May 1986): 125.

Cotter, Holland. "Pat Steir." *Flash Art* (International Edition) 24, no. 159 (Summer 1991): 163.

Crary, Jonathan. "Pat Steir." *Arts Magazine* 50, no. 10 (June 1976): 10.

Crimp, Douglas. "Pat Steir." *ArtNews* 71, no. 6 (October 1972): 82–83.

Danto, Ginger. "What Becomes an Artist Most?" *ArtNews* 86, no. 9 (November 1987): 149–53.

Diehl, Carol. "Pat Steir." *ArtNews* 94 (November 1995): 240.

Forgey, Benjamin. "The Whitney Biennial." *ArtNews* 76, no. 4 (April 1977): 121–22.

French, Christopher. "Style as Content." *Artweek* 16, no. 40 (November 1985): 1 and cover.

Gardner, Paul. "I Dream of a Dazzling Waterfall." *Contemporanea* (October 1990): 44–49.

_____. "Pat Steir: Seeing Through the Eyes of Others." *ArtNews* 84 (November 1985): 80–88.

_____. "What Artists Like About the Art They Like When They Don't Know Why." *ArtNews* 90, no. 8 (October 1991): 116–21.

Glueck, Grace. "Art People." *New York Times,* 14 January 1977.

Godfrey, Tony. *Drawing Today.* London: Phaidon, 1990.

Goldman, Judith. "Woodcuts: A Revival?" *Portfolio* 4, no. 6 (November–December 1982): 66–71.

Gollin, Jane. "Pat Steir." *ArtNews* 69, no. 10 (February 1971): 26.

Graze, Sue. *Concentrations: Pat Steir.* Exh. cat. Dallas: Dallas Museum of Art, 1986.

Grinnell, Gene. "Printed Art Today, Part 4: Crown Point Press." *Mizue* 959 (1991): 108–18.

Haden-Guest, Anthony. "Nudism, Nomadismo Haunt Venice Biennale. *New York Observer,* 5–12 July 1993.

Hoffmann, Katherine. *Explorations: The Visual Arts Since 1945.* New York: HarperCollins, 1991.

Horstfield, Kate. "On Art and Artists: Pat Steir." *Profile* 1, no. 6 (November 1981): 1–22.

Howell, John. "A Bloom of One's Own." *Elle,* February 1988, 102, 104.

Hoy, Anne. "Portrait Photographs from *ArtNews,* 1905–1986." *ArtNews* 86, no. 2 (February 1987): 93–100.

Hughes, Robert. "Myths of Sensibility." *Time,* 20 March 1972, 72–77.

Indiana, Gary. "Pat Steir." *The Village Voice,* 25 March 1986.

Irish Museum of Modern Art. *Pat Steir: A Painting Project*. The Pleasures of Merely Circulating. Zurich, Switzerland: Memory/Cage Editions GmBH, 1995.

Johnson, Patricia C. "A Sensual, Thoughtful Summer." *Houston Chronicle,* 29 July 1992.

Johnson, Stephen and Lucille Aptekar. *Whitehead Institute Art Collection*. Cambridge, MA: Whitehead Institute for Biomedical Research, 1984.

Kafka, Barbara. "Pleasing the Palette." *ArtNews* 88, no. 6 (Summer 1989): 162–65.

Kalil, Susie. "Art: Pat Steir's Paintings, Prints, Drawings." *Houston Post,* 12 June 1983.

Kimmelman, Michael. "Quotations/The Second History of Art." *New York Times,* 21 August 1992.

Larson, Kay. "Artist's Dialogue: Pat Steir—Through Time, Beyond Style." *Architectural Digest* 43 (April 1986): 66, 70, 74, 76.

_____. "The Painting Pyramid." *New York,* 25 May 1992, 85–86.

_____. "Privileged Access." *New York,* 22 July 1985, 61–62.

Laurent, Rachel. "Pat Steir." *Art Press,* no. 46 (March 1981).

Lewallen, Constance. "Pat Steir." *Matrix/Berkeley* (November–December 1985).

_____. "Pat Steir." *View* 7, no. 6 (Autumn 1992).

Liebmann, Lisa. "Documenting Documenta." *Interview* (June 1992): 44–49.

_____. *Pat Steir Waterfalls*. Exh. cat. Tampa: Art Museum, University of South Florida, 1990.

Levin, Kim. "Pat Steir." *The Village Voice,* 11 April 1989.

Mahoney, Robert. "Pat Steir." *Tema Celeste* 29 (January–February 1991): 82.

Marlborough Chelsea. *Pat Steir: Moon Mountain Ghost Water*. Essay by Kay Larson. New York: Marlborough Chelsea, 1999.

Mayo, Marti. *Arbitrary Order: Paintings by Pat Steir*. Exh. cat. Houston: The Contemporary Arts Museum, 1983.

McEvilley, Thomas. "I Think Therefore I Art." *Artforum* 23, no. 10 (June 1985): 74–84.

_____. *Pat Steir*. New York: H.N. Abrams, 1995.

Muschamp, Herbert. "Oil and Water." *Vogue,* July 1990, 200–05, 226.

Navone, Edward. "Art and Words." *Forum,* April 1982, 10–11.

Nuridsany, Michael. "Pat Steir, *un puissance magique*." *Le Figaro,* 16 November 1979.

Nusbaum, Eliot. "Steir Study in Self-Analysis." *Des Moines Sunday Morning Register,* 8 June 1986.

Princenthal, Nancy. "The Self in Parts." *Art in America* (November 1987): 170–73.

"Prints and Photographs Published: Pat Steir." *Print Collector's Newsletter* 9, no. 4 (September–October 1978): 123.

"Prints and Photographs Published: Pat Steir." *Print Collector's Newsletter* 12, no. 6 (January–February 1982): 182.

"Project for *Artforum*." *Artforum* 24 (April 1986): 82–85.

Ratcliff, Carter. Essay/Interview in *Pat Steir Paintings*. New York: Harry N. Abrams, 1986.

Raynor, Vivien. "Art: Pat Steir, the Expressed Self." *New York Times,* 10 March 1978.

Rickey, Carrie. "Beyond the Canvas: Artists' Books and Notations." *Artforum* 17, no. 6 (February 1979): 60–61.

Rose, Bernice. *Allegories of Modernism: Contemporary Drawing*. New York: The Museum of Modern Art, 1992.

Silver, Joanne. "Wave On: Steir Studies the Ebb and Flow of Influence." *Providence Journal-Bulletin,* 23 May 1986.

Simon, Joan. "Expressionism Today: An Artists' Symposium—Pat Steir." *Art in America* 70, no. 11 (December 1982): 74–75.

Simons, Riki. "Pat Steir: Interview (Dutch)." *Avenue Magazine* (December 1987): 150–53.

Slivka, Rose. "From the Studio." *East Hampton Star,* 24 June 1994.

Steir, Pat. "Drawing Now and Then." *WhiteWalls,* no. 13 (Spring 1986): 51.

_____. "Mortal Elements." *Artforum* 32 (September 1993): 38.

_____. *Pat Steir: Gravures/Prints: 1976–1988*. Genève: Cabinet des Estampes du Musée d'art et d'histoire, and London: Tate Gallery, 1988.

_____. "Where the Birds Fly, What the Lines Whisper." *Artforum* 25 (May 1987): 107–11.

_____. "The Word Unspoken." *Artforum* 28 (December 1989): 125–27.

Tarlow, Lois. "Pat Steir (Interview)." *Art New England* 18 (August/September 1997): 77.

Tucker, Marcia. "Interview with Pat Steir." *Journal of the Los Angeles Institute of Contemporary Art,* no. 10 (March–April 1976): 22–25.

Tucker, Marcia. *Pat Steir, Self-Portrait: An Installation*. Exh. cat. New York: The New Museum of Contemporary Art, 1987.

Wechsler, Max. "Paradise Gained (Promenades, Parc Lullin, Genthod, Switzerland)." *Artforum* 24 (September 1985): 94–97.

White, Robin. "Pat Steir, Interview at Crown Point Press." *View* 1, no. 3 (June 1978): 1–6.

_____. "Pat Steir, un expressionisme réfléchi." *Art Press,* no. 18 (October 1980): 17.

"Women Artists." *Bilutsu Techo* 35, no. 515 (September 1983): 82–83.

Yenson, Julie and Thomas McEvilley. *Pat Steir: The Breughel Series (A Vanitas of Style)*. Exh. cat. Minneapolis: Minnesota College of Art and Design, 1985.

Zacharopoulos, Denys. *Pat Steir*. Exh. cat. Lyon, France: Musée d'Art Contemporain, 1990.

_____. *Pat Steir Paintings and Drawings*. Exh. brochure. Bern, Switzerland: Kunstmuseum Bern, 1987.

PHOTOGRAPH CREDITS AND COPYRIGHTS

Frontispiece

Keith McLeod Fund, Courtesy of the Museum of Fine Arts, Boston

Reproduced with permission

© 2000 Museum of Fine Arts, Boston. All rights reserved

Figure 1

Photograph © 1998 Clark Art Institute.

Figure 2

Amsterdam, Van Gogh Museum (Vincent van Gogh Foundation)

Figure 3

Gift of Dexter M. Ferry, Jr.

Photograph © 1989 Detroit Institute of Arts

Figure 4

Gift of Esther and Robert J. Doherty

Courtesy of Herbert F. Johnson Museum of Art, Cornell University

Figure 5

Metropolitan Museum of Art, Alfred Stieglitz Collection, 1949

© 2001 The Georgia O'Keeffe Foundation/Artists Rights Society (ARS), New York

Figure 6

Gift of the Avalon Foundation

Photograph © 2001 Board of Trustees, National Gallery of Art, Washington

Figure 7

Purchase.

Photograph © 2001 The Museum of Modern Art, New York

Figure 8

Gift of Mr. and Mrs. Burton Tremaine

Photograph © 2001 Board of Trustees, National Gallery of Art, Washington

Figure 9

Purchase, with funds from The Lauder Foundation, Leonard and Evelyn Lauder Fund

Photograph by Maggie L. Kundtz, courtesy of PaceWildenstein

© 2001 Estate of Ad Reinhardt/Artists Rights Society (ARS), New York

Figure 10

Purchase, with funds from the Larry Aldrich Foundation Fund

Photograph © 2001: Whitney Museum of American Art

Figure 11

Courtesy of the artist and Cheim & Read, New York

Figure 12

Courtesy of the artist and Cheim & Read, New York

Figure 13

Photography by Jon Abbot, New York

Courtesy of the artist and Cheim & Read, New York

Figure 14

Courtesy of the artist and Cheim & Read, New York

Figure 15

Photograph by Geoffrey Clements

Figure 16

The Musée National d'Art Moderne, Centre Georges Pompidou

Photograph by Zindman/Fremont

Figure 17

Photograph by Glenn Steigelman Inc. Photography, New York

Figure 18

Photograph by Bill Jacobson

Figure 19

The Sidney and Harriet Janis Collection. Photograph © 2001 The Museum of Modern Art, New York

© 2001 The Pollock-Krasner Foundation/Artists Rights Society (ARS), New York

Figure 20

Courtesy of Matthew Marks Gallery, New York

Figure 21

Photograph by Bill Jacobson

Courtesy of Matthew Marks Gallery, New York

Figure 22

Photograph by Greg Heins

Figure 23

Photograph by Greg Heins

Figure 24

Photograph by Greg Heins

Figure 25

Photograph by Greg Heins

Figure 26

Gift of the artist

Photograph by Webber Photography

Figure 27

Photograph by Greg Heins

Figures 28, 29, 30

Photographs by Susan Byrne

Figure 31

Photograph by Susan Byrne

Figure 32

Edward L. Elliott Family Collection

Museum purchase, Fowler McCormick, Class of 1921, Fund

© 1980 Trustees of Princeton University

Reproduced with permission

Photograph by Clem Fiori

Figure 33

Photograph by Susan Byrne

Figure 34

Photograph by Susan Byrne

Photograph credits for plates:

Plates 1–6, courtesy of Cheim & Read;

Plates 7–8, photographs by Zindman/Fremont;

Plate 9, photograph by Oren Slor;

Plate 11, photograph by Bill Jacobson;

Plates 12–16, photographs by Susan Byrne.